How to draw MANGA

COMPILING CHARACTERS

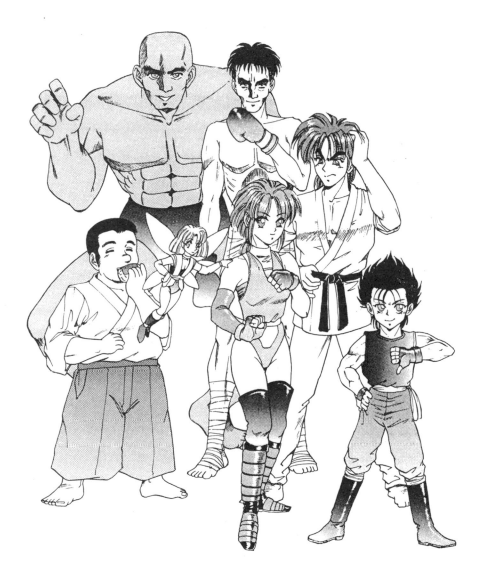

Power up MANGA techniques for beginners

HOW TO DRAW MANGA Volume 1: Compiling Characters
by The Society for the Study of Manga Techniques

Text and images copyright
©1996 by The Society for the Study of Manga Techniques
Design and layout copyright
©1996 by Graphic-sha Publishing Co., Ltd.

This English edition was first published in 1999 by
Graphic-sha Publishing Co., Ltd.
1-9-12 Kudan-kita, Chiyoda-ku, Tokyo 102-0073 Japan

Distributor:
Japan Publications Trading Co., Ltd.
1-2-1 Sarugaku-cho, Chiyoda-ku, Tokyo, 101-0064
Telephone: +81(0)3-3292-3751 Fax: +81(0)3-3292-0410
E-mail: jpt@jptco.co.jp
URL: http://www.jptco.co.jp/

First printing: April 1999
Second printing: November 1999
Third printing: June 2000
Fourth printing: September 2000
Fifth printing: November 2000
Sixth printing: April 2001
Seventh printing: May 2001
Eighth printing: August 2001
Ninth printing: October 2001

ISBN 4-88996-042-2
Printed in Japan

How to draw MANGA

COMPILING CHARACTERS

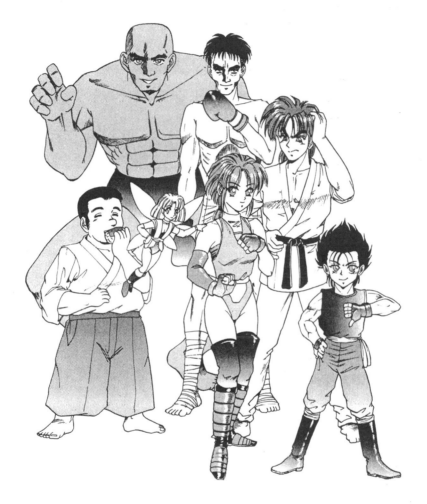

Power up MANGA techniques for beginners

*All the manga characters in this book are fictional and
have nothing to do with actual persons who may exist.

CONTENTS

This book is aimed at those who want to start drawing cartoons (or comics) or those who are at a certain level but want to study it more seriously, or those who are already serious but do not see any improvement. In other words, this book is designed to help all non-professional people, from elementary school pupils to adults to improve their technical skills.

This book concentrates on character types.
Speaking of characters, we guess most of you are confident in your native drawing skill. However, do you vibrate people with life? Are they 3-D? Are body parts smoothly and flexibly jointed?

Here, a group member of the author will teach you the rational method and technique to improve yourself, based on their experiences.

First of all, Chapter 1 will show you how to draw figures, in fully realised 3-D. Chapter 2 will focus on how to draw bodies. It will show how the muscle structure of the body can be rendered, and will enable you to draw human bodies which look quite natural. Chapter 3 will teach you how to draw character. It will enable you to bring out character closer to how professionals do it.

Really? Yes! So why don't you give it a go!

THE SOCIETY FOR THE STUDY OF MANGA TECHNIQUES

REPRESENTATIVE MEMBERS

Hideki Matsuoka
Tatsuhiro Ozaki
Takehiko Matsumoto

Planning: Tatsuhiro Ozaki
Editing : Motofumi Nakanishi
Cover designing and text layout: Hideyuki Amemura
Photographing: Yasuo Imai
English translation: Steve K.Amemura

A PORTRAIT
OF
A CARTOONIST

Written and drawn by

Tatsuhiro Ozaki

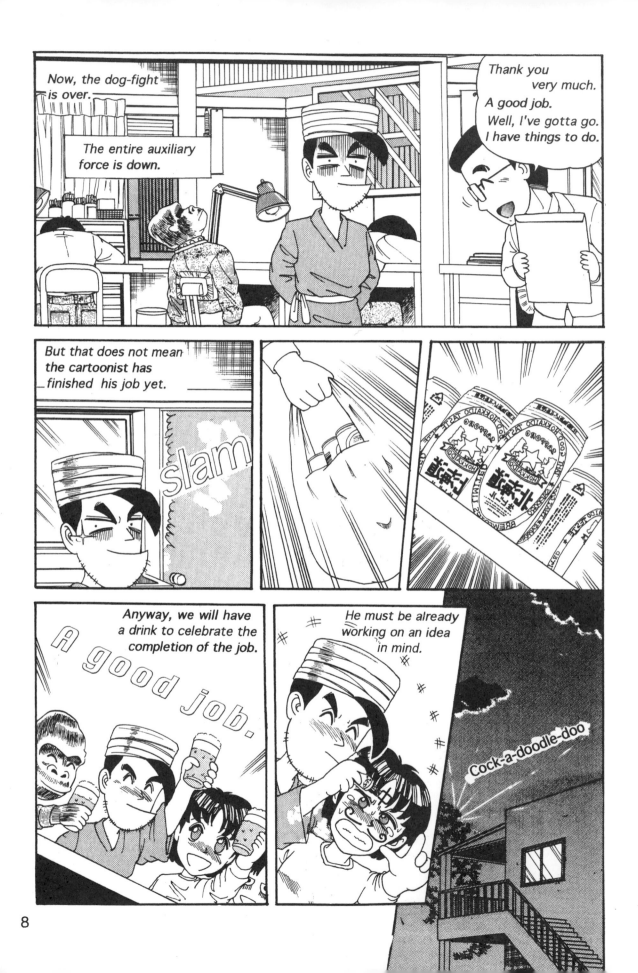

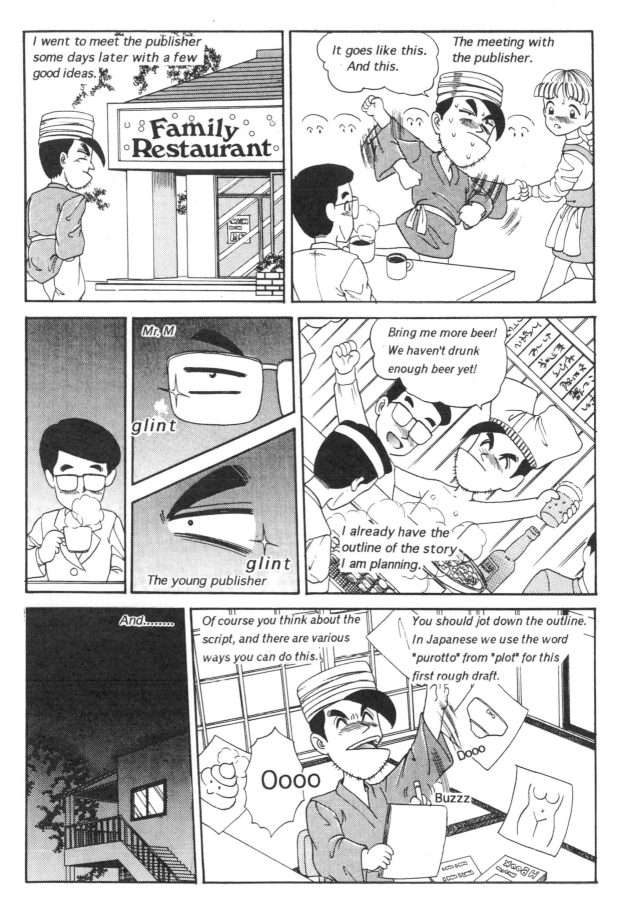

Next, write out the plot developments, one to a page.

Example
Assume that the story of Cinderella is told in 31 pages:

P.1 Cover
P.2 ▾ Cinderella appears.
P.5 Cinderella is treated harshly by her stepmother up to here.
P.6 ▾ The ball at the castle is decided.
P.9 Cinderella is left alone, up to here.
P.10 ▾ The fairy godmother appears.
P.13 The plot moves to the point of the magic
P.14 ▾ pumpkin coach.
P.17 Cinderella debuts at the ball.
P.18 ▾ The Prince appears.
P.21 Cinderella dances, up to here.
P.22 ▾ The clock strikes 12.
P.25 Cinderella runs away, at this point.
P.26 ▾ The Prince seeks Cinderella up to here.
P.29 Cinderella puts on the glass slipper here.
P.30 ▾ The slipper fits and the Prince proposes.
P.31 They lived happily ever after.

The plot must be divided into pages, then the scenario of each page planned out.

Cinderella appears.
The sun has not yet risen.
On a cold morning,
the stepmother and her
daughters are still sleeping.
There is a girl, breathing
white puffs of air,
cleaning the house.
"Oh, it's cold."
"I must finish cleaning the
house and then prepare
breakfast."

Now do your rough illustrations of the script. In Japanese this "picture script" or "e-conte.

The size of the conte should be twice the page size of the magazine. The paper should be high quality B4.

"One-in-two picture" means one picture drawn over two pages.

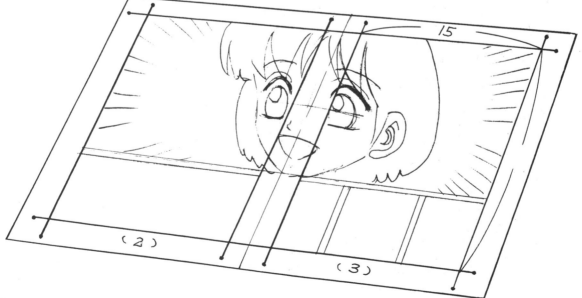

To make your manuscript paper, you must make a master template first.

Pick up several pieces of drawing paper, place the template on top, and then poke 12 holes in it using a compass.

Then draw your frame using the holes as a guideline. You may use a felt tip pen. Use red or blue as it will be easier to see if you decide to draw through to the paper edge.

Fold in two here.

Tachikiri means a frame that goes to the maximum size of the drawing paper.

Again and again, our manga artist quits working on the script and instead goes for a more interesting and cultivated story.

Urgh....

Mm...

But.....

Well, it's time for a drink.

A few days later....

ahhhh

The publishing company comes to him for the name.

Zot!

11

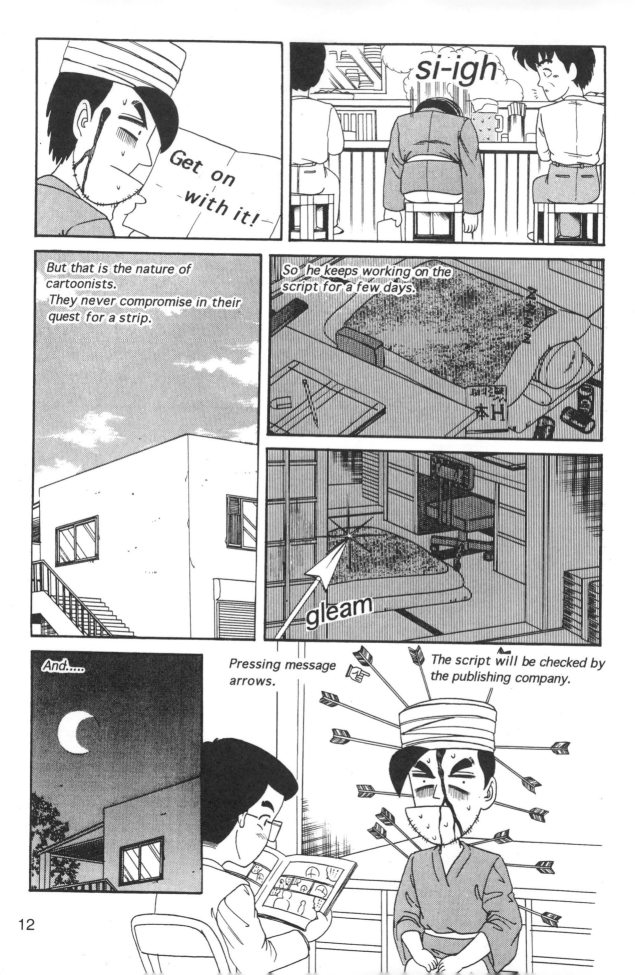

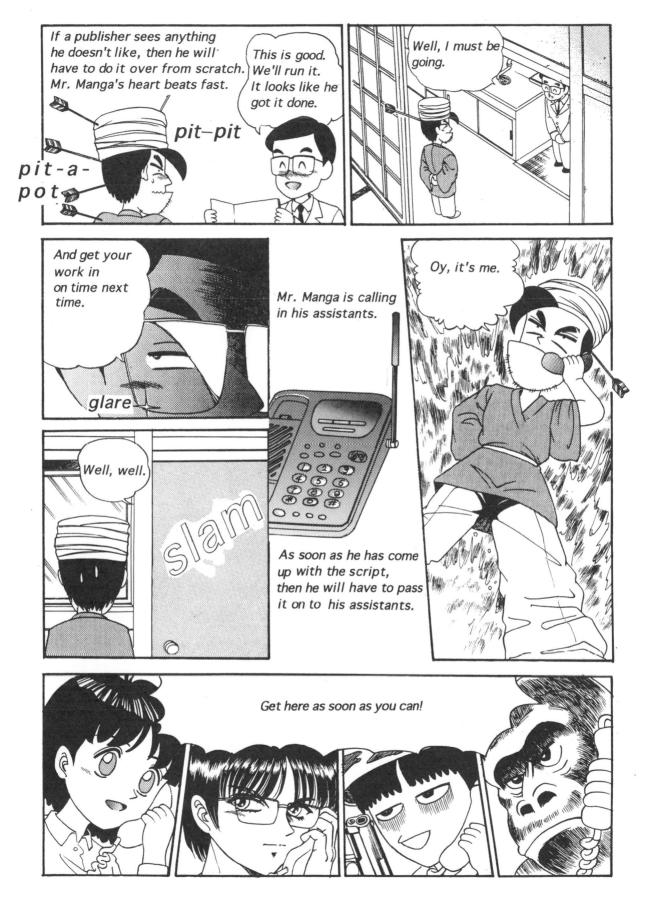

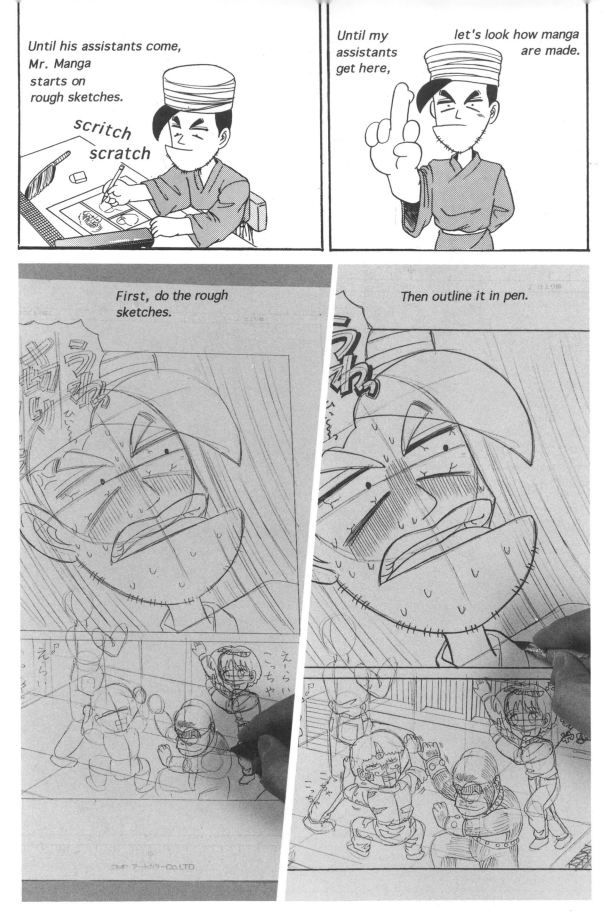

Until his assistants come, Mr. Manga starts on rough sketches.

scritch scratch

Until my assistants get here, let's look how manga are made.

First, do the rough sketches.

Then outline it in pen.

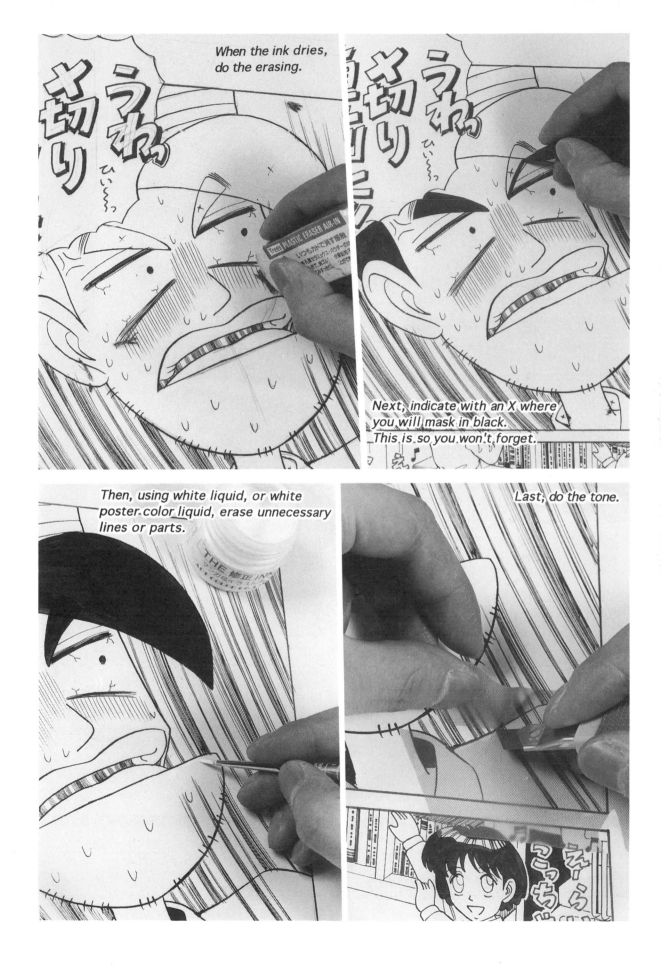

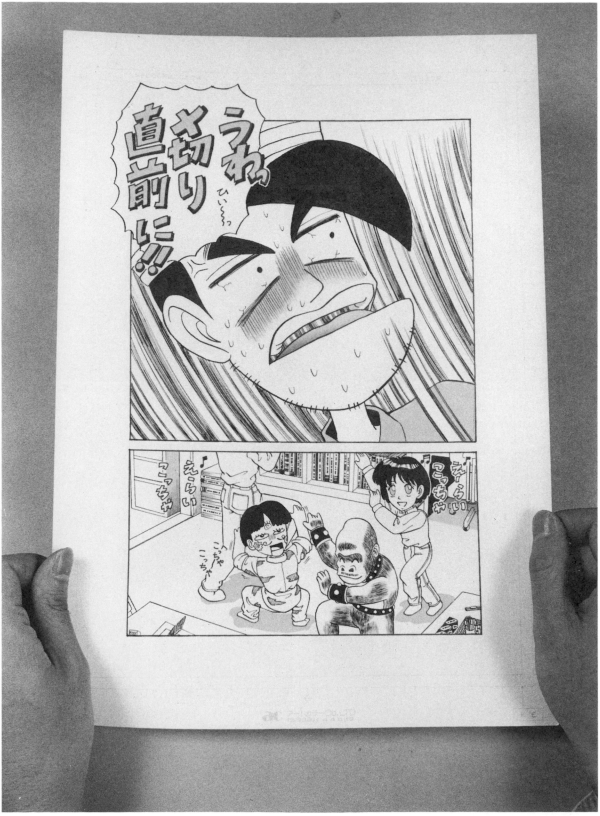

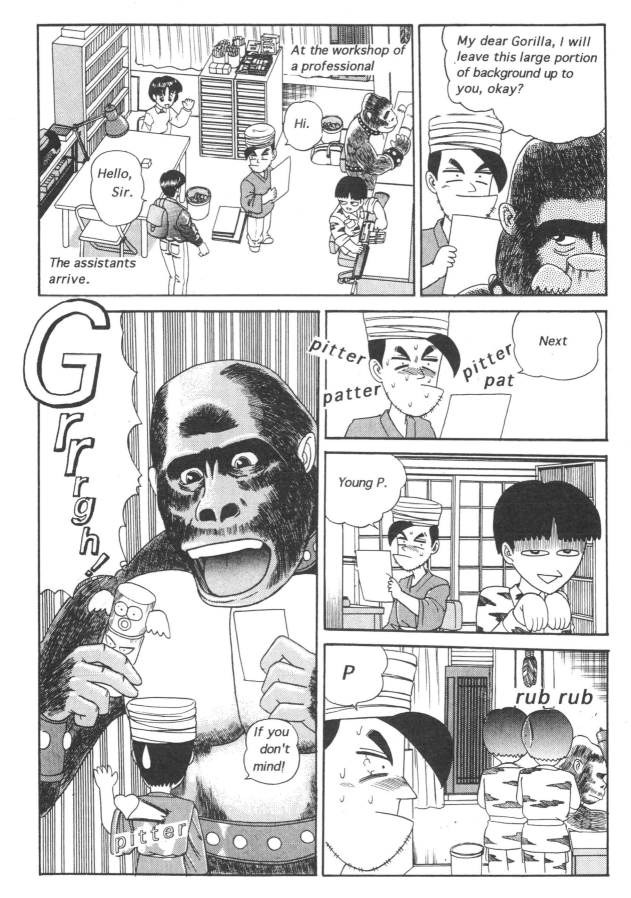

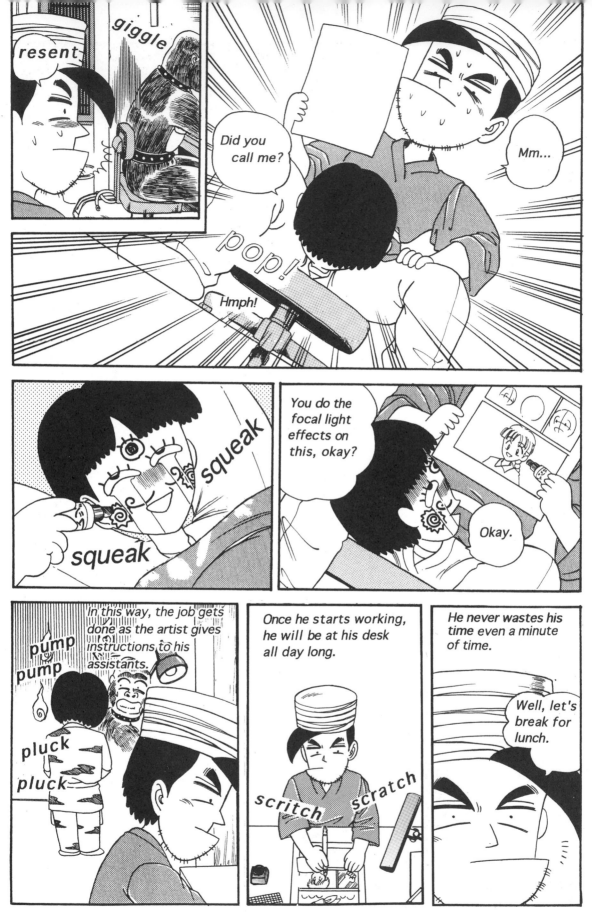

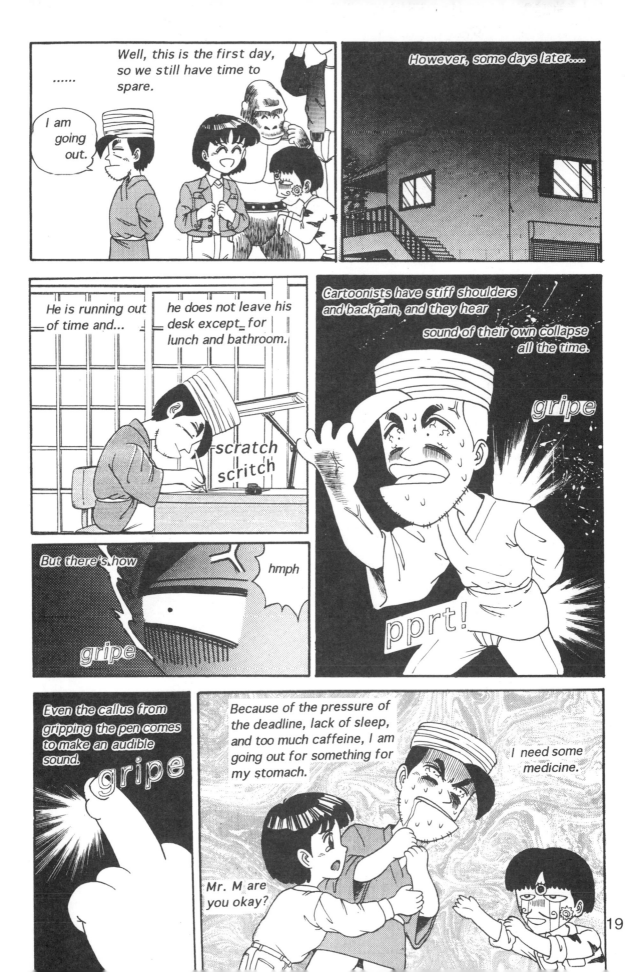

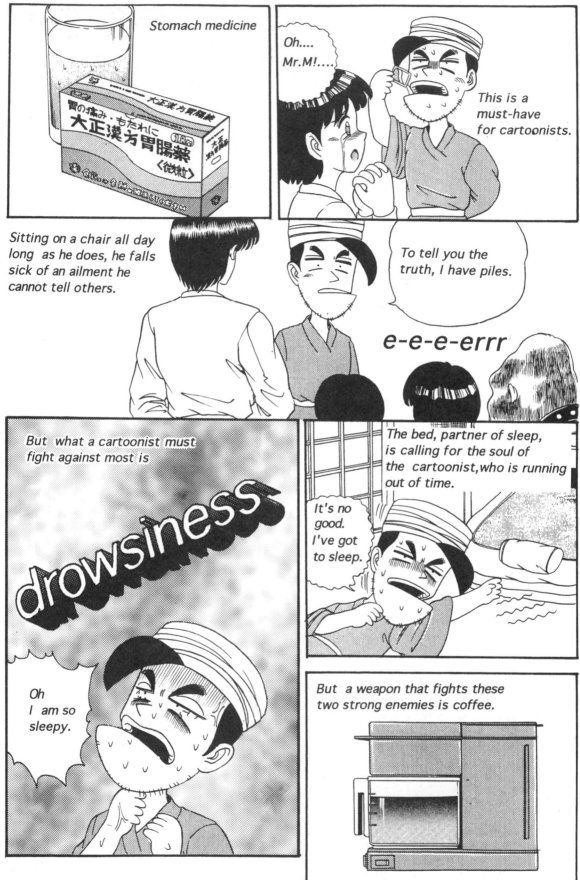

Stomach medicine

Sitting on a chair all day long as he does, he falls sick of an ailment he cannot tell others.

Oh....
Mr.M!....

This is a must-have for cartoonists.

To tell you the truth, I have piles.

e-e-e-errr

But what a cartoonist must fight against most is

drowsiness

Oh I am so sleepy.

The bed, partner of sleep, is calling for the soul of the cartoonist, who is running out of time.

It's no good. I've got to sleep.

But a weapon that fights these two strong enemies is coffee.

slosh

And chewing gum with caffeine in it.

hoo!

splish splash

Damn but it's hot!!

Well, I am awake.

Yet, when the sandman comes again.....

he goes for medicine again.

A tonic medicine drink

A second must-have item for cartoonists

Mr. M!

All the assistants now have to work overnight.

It's time for the last spurt to the finish.

21

The publisher's rep. comes.

Bam!

He pressures the cartoonist who has scarcely any time left to meet the deadline.

cof puff, pant.

Placing the photocompositions....

いらっしゃいませ！

The publisher's rep. pressures the assistants.

Loom

Yeeee

Under all that stress, the cartoonist keeps on working and drawing.

The last lap

Whipping his sleepy body

tick tock

Hurry it up but carefully does it.

I can do it.

INSTRUMENTS & MATERIALS FOR DRAWING MANGA

MANUSCRIPT PAPER

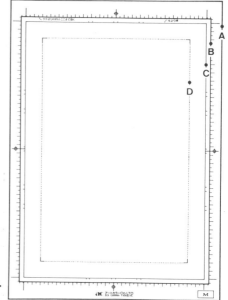

In general, the basic paper used for cartoon manuscripts is high-quality paper(wood free), Kent paper, and drawing paper. However, repeated erasure on drawing paper will roughen its surface and as a result it may not be suitable for beginners because ink will blot. On the other hand, you do not have to worry about blotting with Kent paper (both 90kg and 135kg thicknesses are available) or high-quality paper.

Nowadays, manuscript paper made exclusively for drawing cartoons is available. Kent paper or wood free paper is used and it is printed with light-blue frame-lines for drawing cartoons, and with measurement on the edges that make it easier for partitioning frames and specifying portions of frames that need to be cut off. Recently, cartoonists have been using this specialized cartoon manuscript paper.

A: Size of manuscript paper
(B4 = 257mm x 364mm / A4 = 210mm x 297mm)
B: Draw to this edge when cutting off frames.
C: Outer frame—finish drawing at this edge
(B4 = 220mm x 310mm / A4 = 182mm x 257mm)
D: Internal frame—basic frame for specifying portions
(B4 = 180mm x 270mm / A4 = 150mm x 220mm)

Convenient equipment -
For tape, Scotch tape and Mending tape are good. The photo shows a clear tape. The color and quality of this tape will last. Taping is also good if you make a mistake. Unlike glue, you can peel it off again.

The photo also shows a can of paper cement. There are two types—the spray type and smear type.

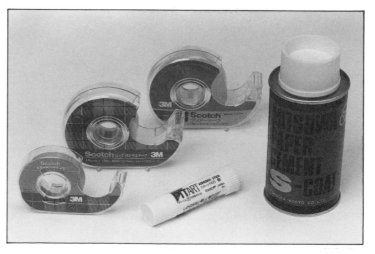

PENCILS

Most cartoonists nowadays use mechanical pencils. Some cartoonists say that they use light-weight pencils when drawing small cartoons for putting weight on pin-points, and larger-gripped ones for drawing large cartoons with a lighter hand. You should choose a suitable lead hardness—HB, B, 2B and so on—by judging the pressure that will bear on the pencil unit. Use B or 2B for weak pencil pressure. Blue lead pencils and mechanical pencils are both very convenient. Blue does not show up when printed; therefore, cartoonists use it to specify tone to their assistants, and or to show where tone is needed, where there is no shade or drawing.

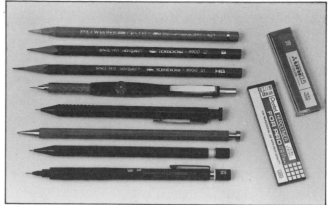

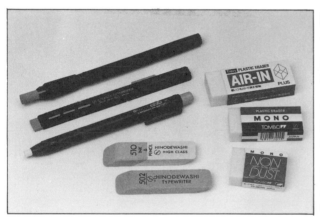

ERASERS

The AIR-IN and MONO series are commonly used erasers (see photo). Residue from erasers may spoil the tone effect if it remains on the paper so be sure to keep your desktop very clean. There is also a very convenient eraser called NON-DUST. This eraser collects the residue by itself and it keeps the working area clean. There is also a pen-type eraser, which is very convenient for erasing in small and narrow spots.
A sand eraser is used to soften tone and bring out a sense of smoothness and dimness.

LIGHT BOXES

A light box illuminates the screen from beneath and makes it possible to draw object through the light from behind. If you have one, it's very useful.

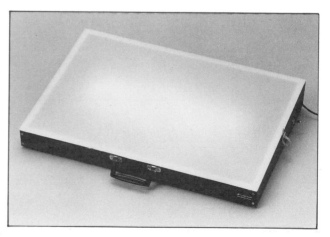

25

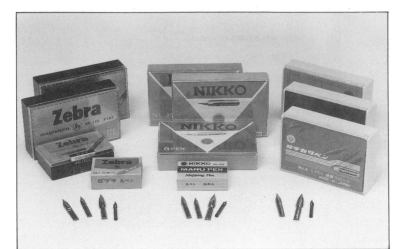

PEN POINTS

Zebra, Nikko and Tachikawa are well known nib manufacturers. For drawing cartoon characters, the G-pen and the Round-pen are most often used. Some cartoonists prefer to use the turnip pen (Kabura Pen) for the hardness of line it gives. Gillotts is an English make, and here are six different types, ranging from fine-pointed to the G-pen type.
They all draw very smoothly.

PENHOLDERS

The pen is something you hold for a long time and if you grip it strongly you may get callouses. When you buy a penholder, keep in mind that though penholders can hold any standard G-pen, turnip pen and school pen, the round pen requires its own exclusive holder.

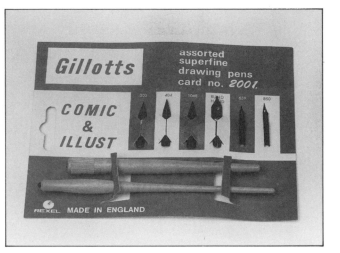

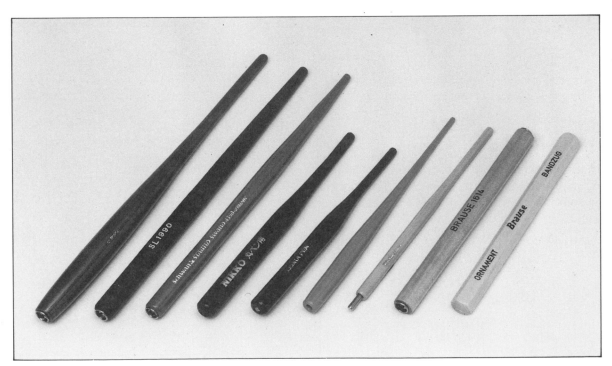

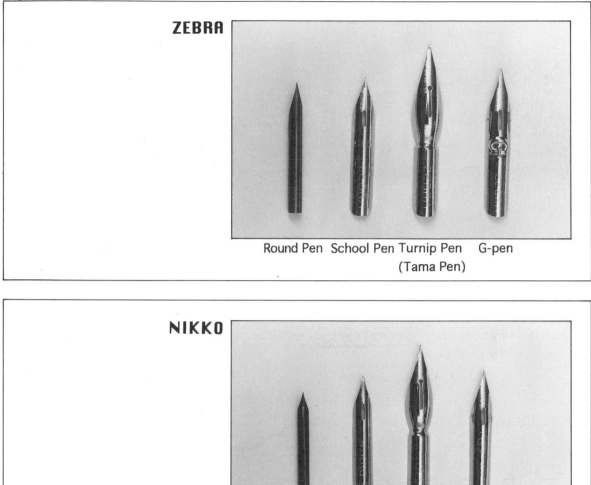

ZEBRA

Round Pen School Pen Turnip Pen G-pen
(Tama Pen)

NIKKO

Round Pen School Pen Turnip Pen G-Pen
(Saji Pen)

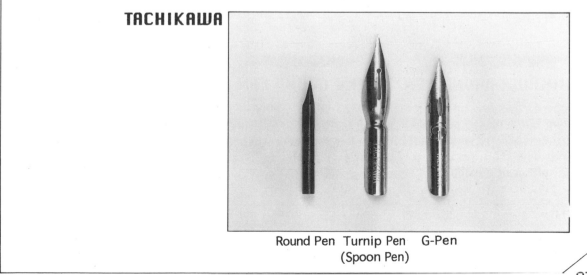

TACHIKAWA

Round Pen Turnip Pen G-Pen
(Spoon Pen)

27

TACHIKAWA G-PEN

You can get uniform vertical and horizontal lines with this pen. It has a hard, direct touch.

NIKKO G-PEN

This pen has a very smooth and easy flow. It is suitable for drawing thicker rather than fine lines.

ZEBRA G-PEN

Both fine lines and thick lines can be drawn with this pen. Its soft touch produces soft lines. Many cartoonists use this pen, although you may feel a slight resistance in flow.

TACHIKAWA ROUND PEN

This pen draws fine lines, of course, but it is also possible to draw relatively wide lines, and has a good feeling to it, close to that of the Zebra G-Pen.

NIKKO ROUND PEN

You may feel it is designed exclusively for drawing fine lines. It scratches the paper when drawing bold lines, and may require some getting used to.

ZEBRA ROUND PEN

Basically, this pen is designed for drawing fine lines, although it is possible to draw bold lines. It may scratch the paper a little bit, but once you become used to it, it will give you very good results:

TACHIKAWA TURNIP PEN

With this pen you can draw very uniform lines, and the feeling is very free flowing. A combination of both a fine point pen and a Rotring yet some touching is also possible.

NIKKO TURNIP PEN

The pen point has a yielding feel. The line drawn may be a little thicker than those drawn by Tachikawa but it has a similar feeling.

ZEBRA TURNIP PEN

This turnip pen is designed to draw hard and even lines. You may have some difficulty at first, but this pen is commonly used.

NIKKO SCHOOL PEN

This pen point is a little bit softer than Zebra. The lines are a little bit bolder.

ZEBRA SCHOOL PEN

This nib is good for drawing fine and hard touch lines. The School Pen gives hard lines, whereras the round pen creates soft lines.

Each person has own preference in pen nibs. Try out different types of pen points from different manufacturers in order to determine what works best for you.

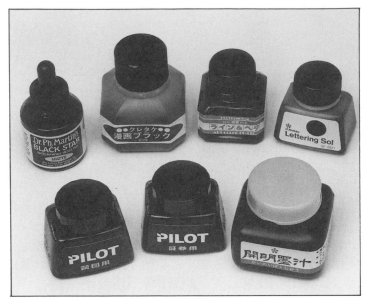

INK

Some of the commonly used inks and Kaimei Bokuju (China Ink). Kaimei Bokuju does not dry as fast as Pilot, but there will be no problem if you keep a roll of absorbant paper (toilet rolls work fine!) handy for blotting up excessive ink(See illustration).

Pilot ink for writing documents is water-resistant, and used for drawing in color. Nowadays, many other good inks have also become available.

Dr. Martin's, Line & Beta and Lettering Sol, out of the upper four inks in the photo, are water-resistant.

The strength of the black, including Cartoon Black, is much higher than Pilot or Kaimei Bokuju, and they provide a spotless finish.

HOW TO WIPE OFF INK

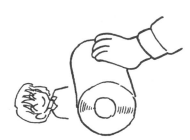

(1) Place the roll of paper on the drawing.

(2) Roll it over once only. Do not push down otherwise the lines may smear.

(3) Do not reverse roll to avoid spots.

WHITE INK · CORRECTION FLUID

Correction fluid may be applied to correct tone and copies, as long as it is not watery. It is not necessary to dissolve it in water, and it spreads well. Correction ink is convenient to have. Simple mistakes can be corrected.

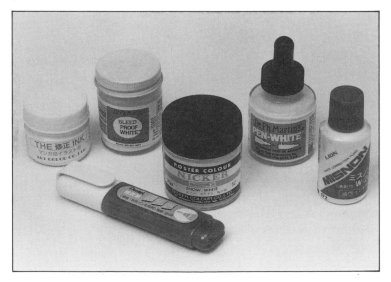

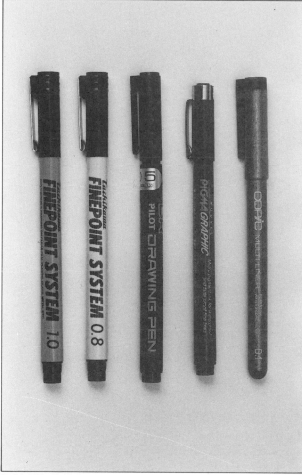

FINE POINT PENS

Drawing cartoons does not require preciseness to the milimeter. Some cartoonists use fine point pens as they are easy to obtain and easy to maintain.

BRUSHES

Very slim brushes are recommended for white ink or correction fluid. Correcting can be very precise depending upon the brush used.

BRUSH PENS

Nowadays, brush pens are commonly used for black masking. For large areas, the brush pen on the right in the photo is more suitable. This pen will be also good for drawing highlights in hair.

The brush on the left feels more like a pen, more like drawing than painting.

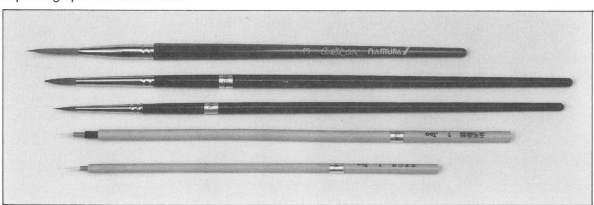

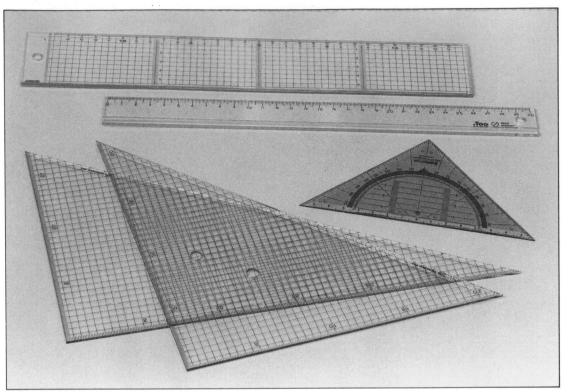

RULERS

Basically, you should choose beveled rulers for lines, and rulers with measurements will be more convenient to use. You should have at least three different types of rulers: a 14cm ruler for fine work, a 30cm ruler for frame work, and a 40~50cm type ruler for long perspectives.
Rulers with metal edges are also useful because you will not damage the ruler when using a cutter.

The pen should be positioned as in the left diagram, so that the ink does not come below the edge of the ruler when drawing with pens.

"Edge" means the beveled edge.

See the diagram on the right for the correct positioning of pencils.

CURVED RULERS

Be sure to use rulers with an ink edge when using curved rulers or templates. Round chip floating discs are used for preventing seepage you attach them to the back of the ruler, lifting it slightly from the paper.

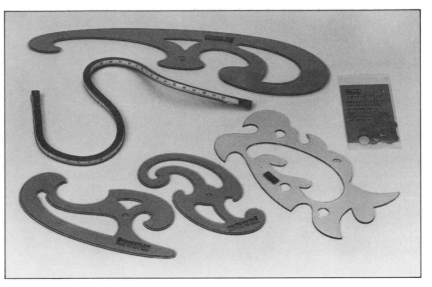

FLEXIBLE RULERS

These rulers can be made into any curve you want but they do not have an edge; therefore, you must use a fine nib with them.

TEMPLATES

Oval and circle templates are very handy to have.

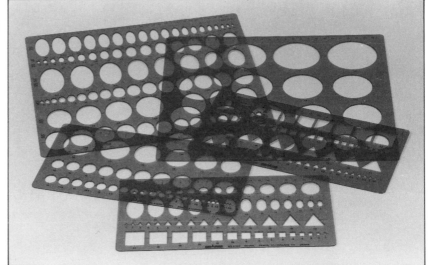

COMPASSES

The type of compasses shown are very useful for not only drawing circles but also for use with a cutter for tone sheets.

No.1033(Letraset)

C-188(Letraset)

No.684(Letraset)

No.61(Letraset)

TONES

Nowadays, tone is indispensable for drawing cartoons. Make sure that the manuscript paper is free from dust and erase residue. If it sticks to the tone paper you won't be able to use it. The sheets are packed individually in clear plastic bags. They should be put back after use. This #61 refers to Letraset #61 and tone of this dot size is called Screen-Tone. Letraset #684 looks like sand; therefore, it is called sandy dot.

PORTFOLIOS
The portfolio is a bag designed for carrying manuscript paper and leaves of tone, so it protects your work even on crowded trains.

S-428(IC)

S-452(IC)

S-686(IC)

S-51(IC)

Tone, dot-tone and gradation create half-tones from black to white. There are also different types of tones such as tone for use in backgrounds and or for garments and other textures.

The cut and paste type is not the only kind of tone. Transfers are also available. Which type you use will depend on the situation.

Illust Tex (I.C.)

Instantex (Letraset)

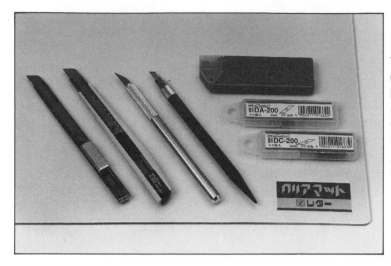

TONE GOODS

Tone always comes with a cutter. You should start with a standard type. Cutter blades quickly wear out and become dull. As a result, it affects on your work. Make sure to break off the blade edge as often as possible so that you have always a sharp blade. An art cutter is useful for special techniques. Standard cutters should be gripped the same way as you hold pencils. A Clear Mat is useful and protects your desk when placed under the manuscript paper when cutting and pasting.

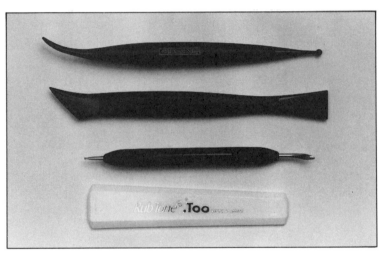

They are called Tone-Bera or Tone-scrubber and pointed ones are more convenient.

Feather brushes sweep off not only eraser residue but also tone trimmings.

CHAPTER 1
DRAWING THE FACE

By Yu Kinutani/Media Works/Dengeki Comics EX/
from "Angel Arm"

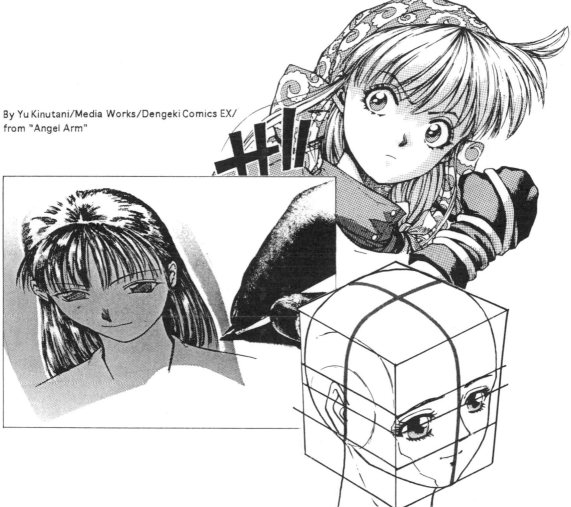

DRAWING CHARACTER-THE FACE

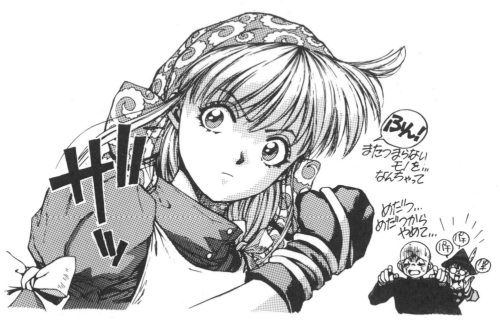

By Yu Kinutani/Media Works/Dengeki Comics EX/from "Angel Arm"

Go ahead and draw the face of one of your original characters.
As you do so, think about the drawing and the shape.

Figure 1

You will see how flat the side of the human face is when eye position and ear position are connected with lines.

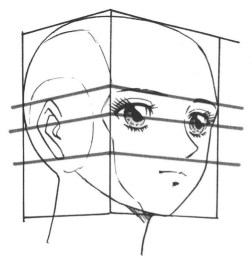

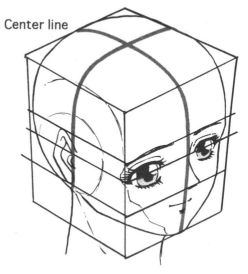

Center line

Figure 2

Also, if the ear position is carried up by line, you see it will intersect the center of the bisecting line of the head.

Figure 3

The human skull is composed of two parts, the upper portion of the skull and the lower jaw. These two get together and become one.

Check with the center line if the right and left side are balanced.

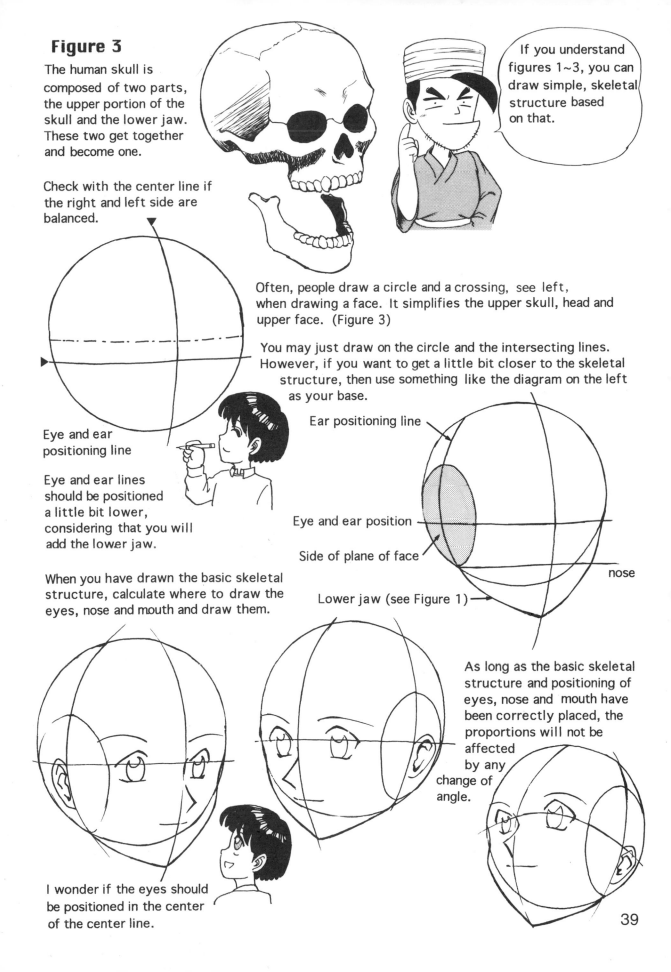

If you understand figures 1~3, you can draw simple, skeletal structure based on that.

Eye and ear positioning line

Eye and ear lines should be positioned a little bit lower, considering that you will add the lower jaw.

When you have drawn the basic skeletal structure, calculate where to draw the eyes, nose and mouth and draw them.

Often, people draw a circle and a crossing, see left, when drawing a face. It simplifies the upper skull, head and upper face. (Figure 3)

You may just draw on the circle and the intersecting lines. However, if you want to get a little bit closer to the skeletal structure, then use something like the diagram on the left as your base.

Ear positioning line

Eye and ear position

Side of plane of face

nose

Lower jaw (see Figure 1)

As long as the basic skeletal structure and positioning of eyes, nose and mouth have been correctly placed, the proportions will not be affected by any change of angle.

I wonder if the eyes should be positioned in the center of the center line.

39

Side and front views of basic skeletal structure

The hairline

You see the vertical line from the ear.

about 45° angle

The hairline

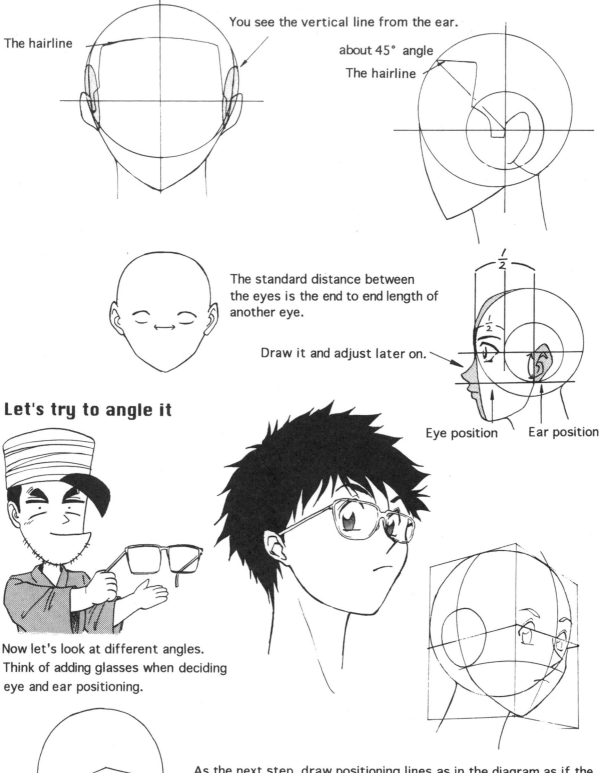

The standard distance between the eyes is the end to end length of another eye.

Draw it and adjust later on.

$\frac{1}{2}$

$\frac{1}{2}$

Eye position Ear position

Let's try to angle it

Now let's look at different angles. Think of adding glasses when deciding eye and ear positioning.

As the next step, draw positioning lines as in the diagram as if the entire face were the side of a box. Now angle the lines.

Faces with different angles

With different perspective, facial proportions will change accordingly.

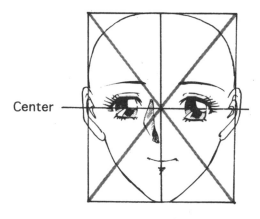

Center

First, partition the face into four squares, then draw the diagonals to find the center.

Assume that the eye position comes to the center. When the figure on the left is angled, you will get the figures below.

This is a figure seen from above and from below. You will see that if you draw from near to far then the proportion of the forehead will become different.

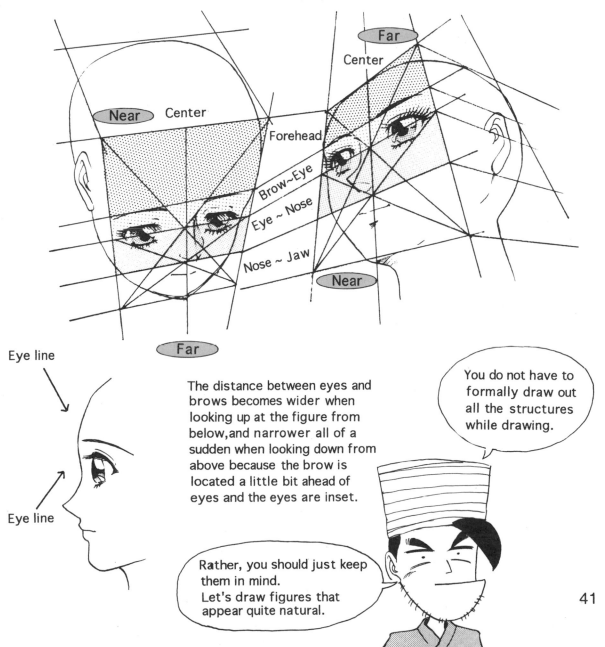

Far

Center

Near Center

Forehead

Brow~Eye

Eye ~ Nose

Nose ~ Jaw

Near

Far

Eye line

Eye line

The distance between eyes and brows becomes wider when looking up at the figure from below, and narrower all of a sudden when looking down from above because the brow is located a little bit ahead of eyes and the eyes are inset.

You do not have to formally draw out all the structures while drawing.

Rather, you should just keep them in mind. Let's draw figures that appear quite natural.

HOW TO DRAW FACES (Application)

When the basic skeletal structure and the position of eyes and nose is decided then adjust the facial contours. There will be no problem as long as the skeletal structure of face is drawn in accordance with the basic skeletal structure but if not then adjust it in your own way.

This line basically needs to be lined on top of nose, but let's divide it in your own way.

Try to think about the basic skeletal structure so that it matches with the skeletal structure of each character and pattern.

Some patterns do not require drawing a plane of the side of the face. By the way, the way that Mr. M draws is this.

This is the position of the ear.

The circle alone forms the basis of the entire facial pattern.

Add the lower jaw and adjust the outline of the face.

Adjust the shape of the head such as the back of the head, etc.

The way Mr. M draws can be applied to many other drawings.

42

How to draw skeletal structure differently.

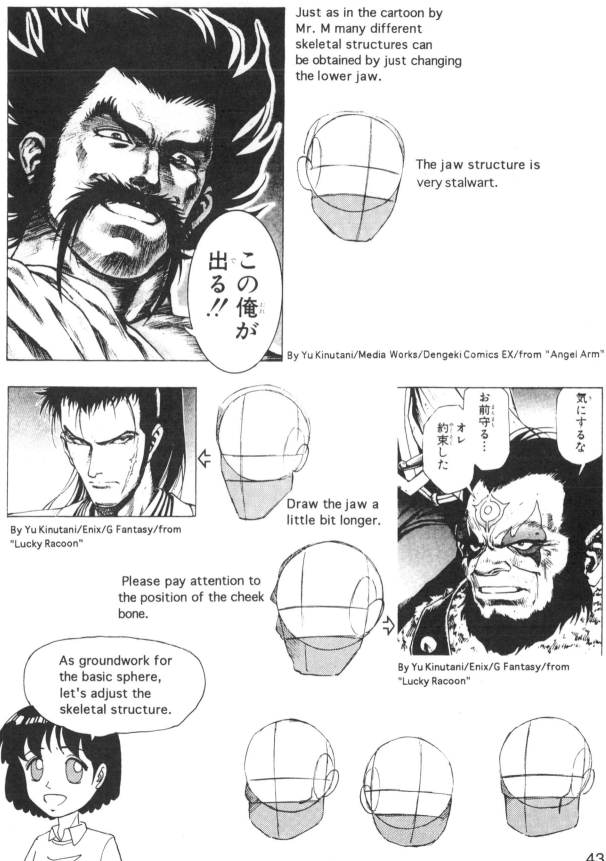

Just as in the cartoon by Mr. M many different skeletal structures can be obtained by just changing the lower jaw.

The jaw structure is very stalwart.

この俺が出る!!

By Yu Kinutani/Media Works/Dengeki Comics EX/from "Angel Arm"

By Yu Kinutani/Enix/G Fantasy/from "Lucky Racoon"

Draw the jaw a little bit longer.

Please pay attention to the position of the cheek bone.

気にするな

お前守る…オレ約束した

By Yu Kinutani/Enix/G Fantasy/from "Lucky Racoon"

As groundwork for the basic sphere, let's adjust the skeletal structure.

FACIAL EXPRESSION

The body part that shows expression of the heart most is the face.

Facial Expression

When the expressions of the character are drawn vividly, your work will be impressive indeed.

Normal state

Emotionless Expression

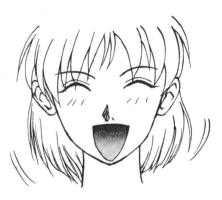

Loud laughter

The louder the laugh, the more the heart is expressed. The mouth opens wider and more voice wants to come forth.

Laughter

Depending upon the degree of laughter, the eyes narrow.

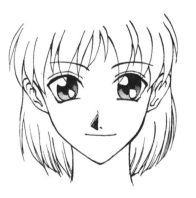

Smile

When happy, the outside facial muscle loosens and eyebrow, eyes and mouth are drawn in a curved line.

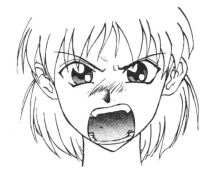

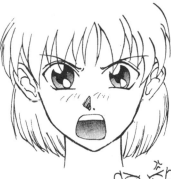

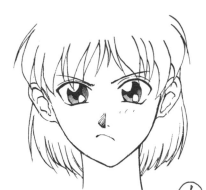

Violent anger

When very angry, the ends of the eyes lift up.

Anger

Depending upon the degree of anger, wrinkles show up in the middle of the face.

Being upset

When angry, the muscles bunch together into the center.

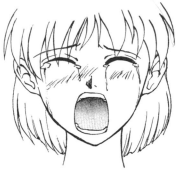

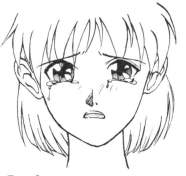

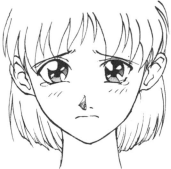

Crying loudly

When crying loudly, the eyes may open but it depends on the emotional strength of the heart.

Crying

The eyelids are pulled by the muscles of eyebrows.

Sorrow

When sorrowful, the eyebrows will bend backward.

Thinking

When you look at someone who is speaking while thinking, you see that their gaze is averted.

Troubled

This expression is similar to sorrow.

Surprise

With surprise, the eyes widen. A useful tip is to draw sweat in order to look like the way it should be.

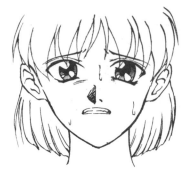
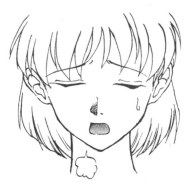
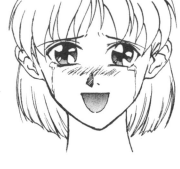

Fright

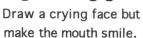

When frightened, the face looks pale or tense.

Relief

The eye shape here is the main point.

Cry smilingly

Draw a crying face but make the mouth smile.

Expression is composed of movements of eyebrows, eyes and mouth. Even in cases of deformation, you will be able to express what you want if you understand the basic shapes of those movements.

The difficulty of creating expression is that there are slight differences in even laughing depending on each situation.

By Yu Kinutani/Enix/G Fantasy/from "Lucky Raccoon"

Study different ways of drawing expressions in cartoons by looking at your own face in the mirror and see how to create expression yourself.

"So what's with you?!"

Studying how to position the eyes

HOW TO EXPRESS AGES

The difference between adults and children

Please have a look at the drawings below.
The proportions of eyes and nose are
different between adults and children.

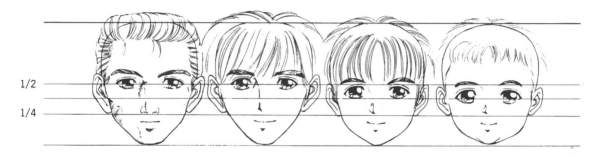

1/2
1/4

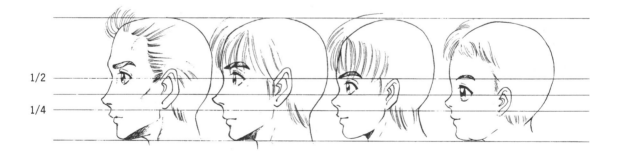

1/2
1/4

Basic partitioning of the head

The eyebrow line falls at 1/2 in infancy,
but the eye line position becomes higher
with maturity.
Adult partitioning starts from age 16.

Facial expression at different ages

Let's look at the difference in expression at various ages.

By Yu Kinutani/Media Works/Dengeki Comics EX/from "Angel Arm"

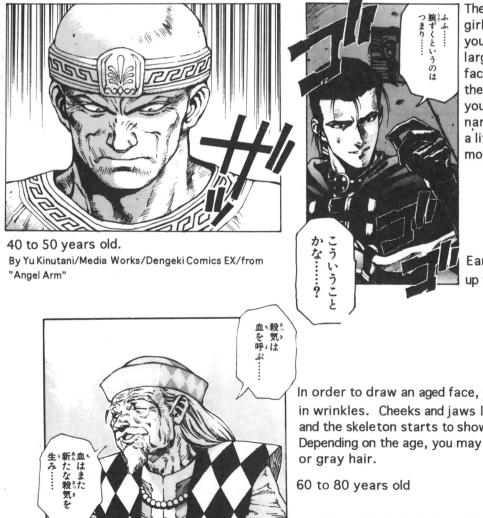

40 to 50 years old.
By Yu Kinutani/Media Works/Dengeki Comics EX/from
"Angel Arm"

The difference between girls and women is that you draw girls' eyes larger and use child's facial proportions on the other hand,when you draw the eyes narrower and the nose a little longer, it looks more adult.

Early twenties and up to 30 years old

In order to draw an aged face, you simply put in wrinkles. Cheeks and jaws loosen downwards, and the skeleton starts to show through. Depending on the age, you may draw thinner hair or gray hair.

60 to 80 years old

By Yu Kinutani/Media Works/Dengeki Comics EX/from "Angel Arm"

The difference between men and women

By Yu Kinutani/Media Works/Dengeki Comics EX/from "Angel Arm"

There is almost no difference in the facial construction between men and women, however, you draw the woman's face a little bit smaller than the man's face, and the woman's eyes a little bit bigger, the mouth and the nose a little bit smaller. By drawing the mouth and nose a little bit smaller, the effect is more delicate and cute. In order to draw manliness, draw the mouth and nose a little bit larger.

DRAWING HAIR

How to draw hair

You may want to draw floating hair, as when the character moves or the wind blows. Movement can also create wind and floating hair.

A so-called head-wind is created from the direction the movement goes into.

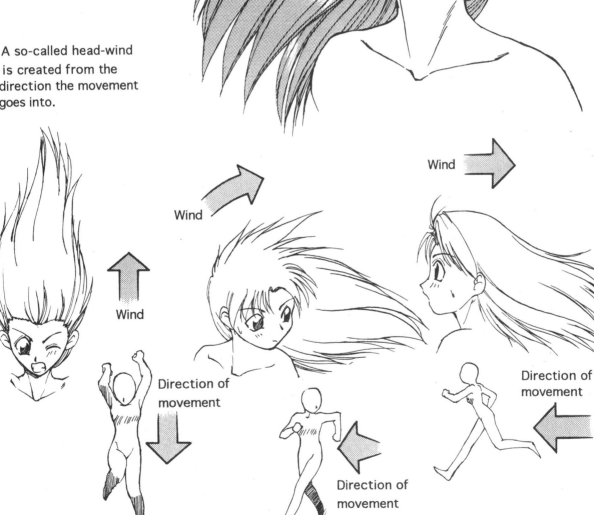

Wind

Wind

Wind

Direction of movement

Direction of movement

Direction of movement

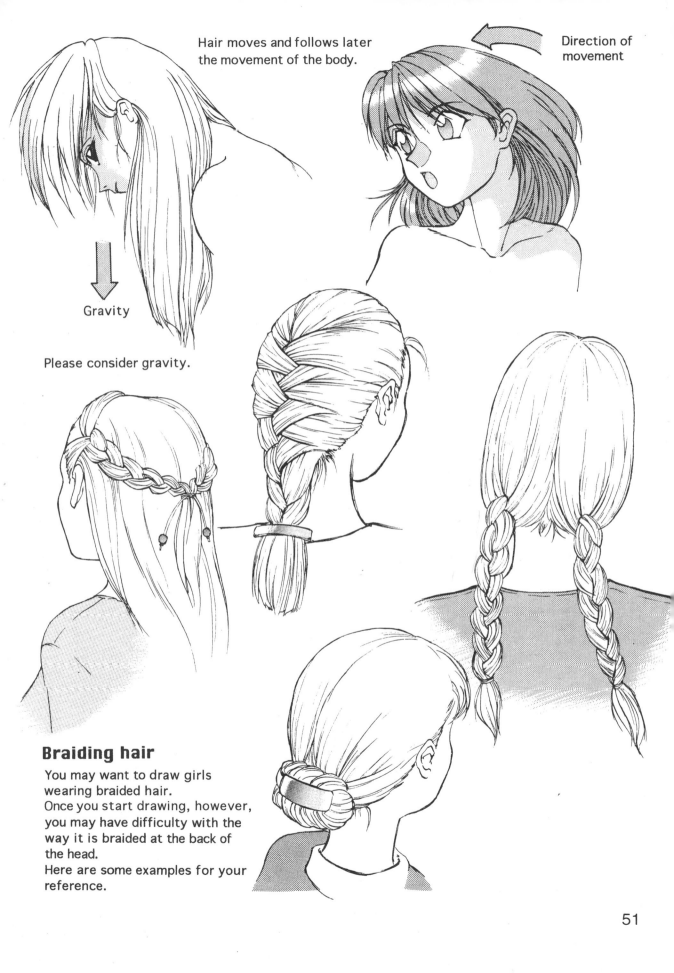

Hair moves and follows later the movement of the body.

Direction of movement

Gravity

Please consider gravity.

Braiding hair

You may want to draw girls wearing braided hair.
Once you start drawing, however, you may have difficulty with the way it is braided at the back of the head.
Here are some examples for your reference.

Continued...
how to draw hair

Here we try several kinds of hair highlights using a brush-pen and/or tone.

Drawing highlights as if you were drawing hair strand by strand.

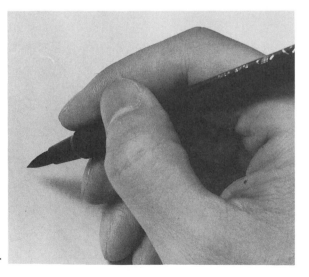

Brush Pen

②Start drawing over the rough copy, using a brush pen.

When you draw highlights, you should use less than 1mm of the brush pen tip.

Sharpness is the key point.

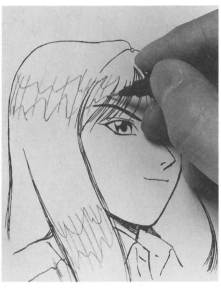

①Think about the hair movement when you want to draw highlights, and make a rough copy.

If your grip is not correct, you may not be able to draw lines well.

Mmmaahh

③ Move the brush pen with your index finger only. Keep your thumb fixed.

Fix the thumb. ▶

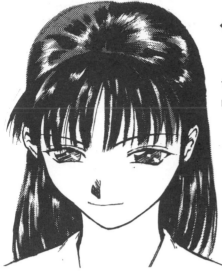

◆ Brush

A fine, broken-in brush with a rough tip gives the best results.

Drawing the outline in blue

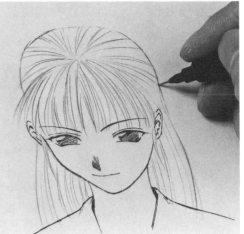

① Draw first a rough copy including the flow of hair. Then use the blue pencil to draw the outline of the head. A light blue pencil doesn't show up in print if you use it gently.

☞ Completed drawing

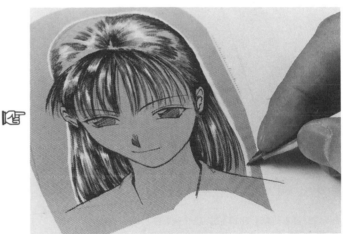

② Now draw in the outline matching the touch with previous frames. Later on, you can adjust it with a pen or brush.

③ Cover the image roughly with tone (use IC#63) then cut out the figure part. You roughly cover it because you can take it off immediately if you make a cutting mistake. Also, you can avoid cutting adjacent tone.

Ink

India ink

If you do not have a used brush, make one in these ways.

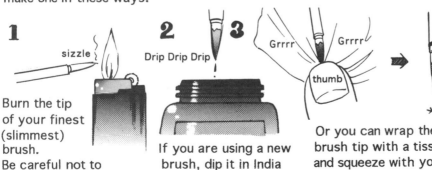

1
sizzle

Burn the tip of your finest (slimmest) brush.
Be careful not to burn the tip too much. About 0.5mm is enough.

2 Drip Drip Drip **3** Grrrr Grrrr thumb

If you are using a new brush, dip it in India ink and let it sit for a while to roughen the tip.

Or you can wrap the brush tip with a tissue and squeeze with your thumb to make the end ragged.

4 India ink

When you use India ink, make sure that you just dip the tip in to draw.

N.B. Use India ink or specialized ink only, other types of ink may damage the brush.

Tone (Cutting · Whitening)

Place the tone.
Draw the hair flow in blue before you start cutting.

How to hold the cutter

Use the blade tip to cut.

Hold the cutter in the same way you hold a pencil.

When you cut the tone, place a piece of paper on top of it, in order to avoid spoiling the tone or the white area when trimming. Basically, any type of paper can be used as long as it does not spoil the drawing but a semi-transparent paper may be convenient.

Rub-Rub-Rub

Draw a rough copy in blue and paint in white. (White liquid exclusively designed for drawing cartoons does not require an eraser, and if you do not thin too much, you can use it on the tone and it will not lift.)

Use the eraser before white liquid on the tone.

Replacing with white

This means painting in white and replacing black or other dark color with white.

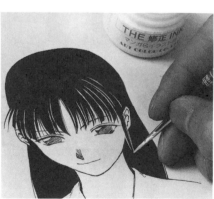

For clearer hair outlines, use this technique after first painting the black.

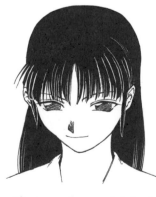

If you make a mistake in white, use a brush pen to adjust it.

A shine in the eye can be drawn with white liquid.

DEFORMATION

How to draw deformations

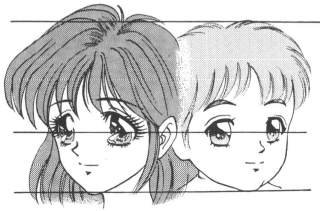

Cartoons are deformed sketches, and they need not reflect the reality. As long as they look good to the eye and or are interesting to see, then everything is OK.

Dividing the facial proportions

You may use the facial proportions of children even for adults for a cute look.

Why eyes are drawn large

You may draw eyes big not only because they look cute but also because sometimes the character looks small depending upon the cut, yet you may still want to have the character stay as a main player.

Delicate angling of the face

As you can see in the illustration, even if drawing eyes is difficult because of the angle....

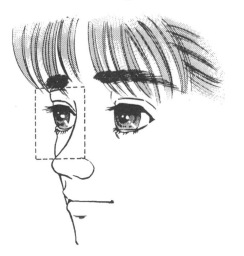

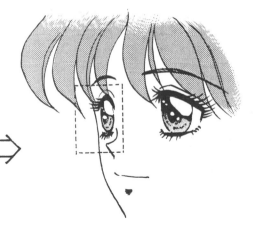

... you may draw the eye a little bit smaller (deformation) and it turns out well.

In drawing a cartoon face, you are free to draw whatever you like

A face can be composed of only eyes and a mouth. As long as people can recognize it as a face, any shape is OK.

Let's think about different deformations. Funny faces provide some of the most interesting aspects of cartoons.

SUMMARY

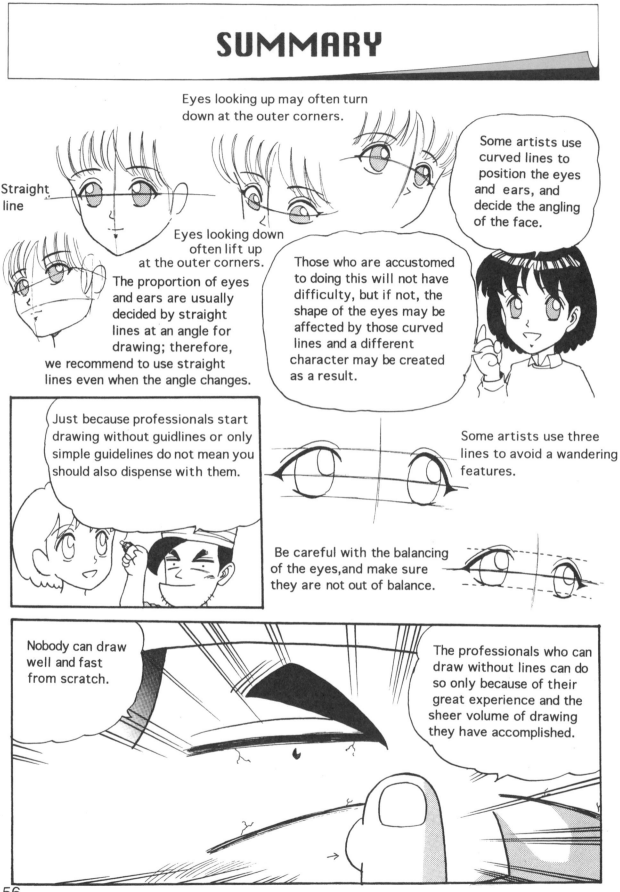

Eyes looking up may often turn down at the outer corners.

Straight line

Some artists use curved lines to position the eyes and ears, and decide the angling of the face.

Eyes looking down often lift up at the outer corners.

The proportion of eyes and ears are usually decided by straight lines at an angle for drawing; therefore, we recommend to use straight lines even when the angle changes.

Those who are accustomed to doing this will not have difficulty, but if not, the shape of the eyes may be affected by those curved lines and a different character may be created as a result.

Just because professionals start drawing without guidlines or only simple guidelines do not mean you should also dispense with them.

Some artists use three lines to avoid a wandering features.

Be careful with the balancing of the eyes, and make sure they are not out of balance.

Nobody can draw well and fast from scratch.

The professionals who can draw without lines can do so only because of their great experience and the sheer volume of drawing they have accomplished.

CHAPTER 2
HOW TO DRAW BODIES

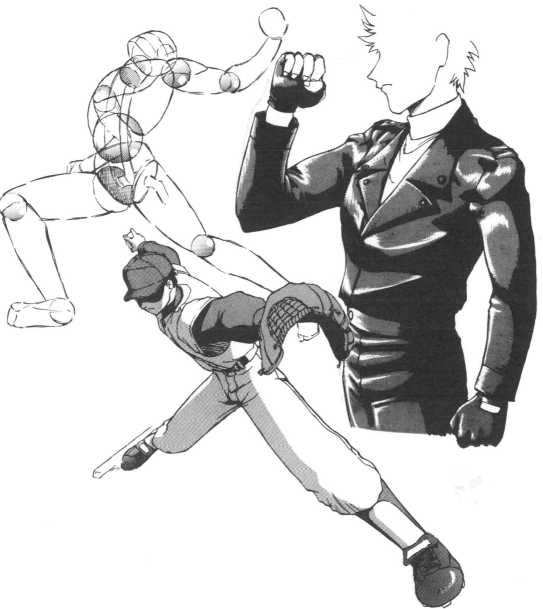

DRAWING CHARACTER BODIES

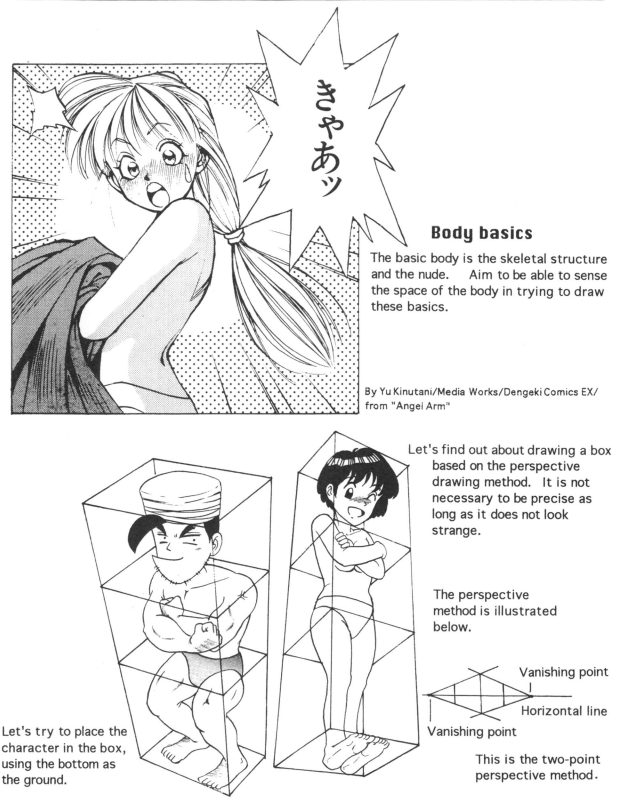

きゃあッ

Body basics

The basic body is the skeletal structure and the nude. Aim to be able to sense the space of the body in trying to draw these basics.

By Yu Kinutani/Media Works/Dengeki Comics EX/ from "Angel Arm"

Let's find out about drawing a box based on the perspective drawing method. It is not necessary to be precise as long as it does not look strange.

The perspective method is illustrated below.

Vanishing point

Horizontal line

Vanishing point

This is the two-point perspective method.

Let's try to place the character in the box, using the bottom as the ground.

A skeletal structure that moves smoothly

Let's look briefly at the skeletal structure and try to draw it.

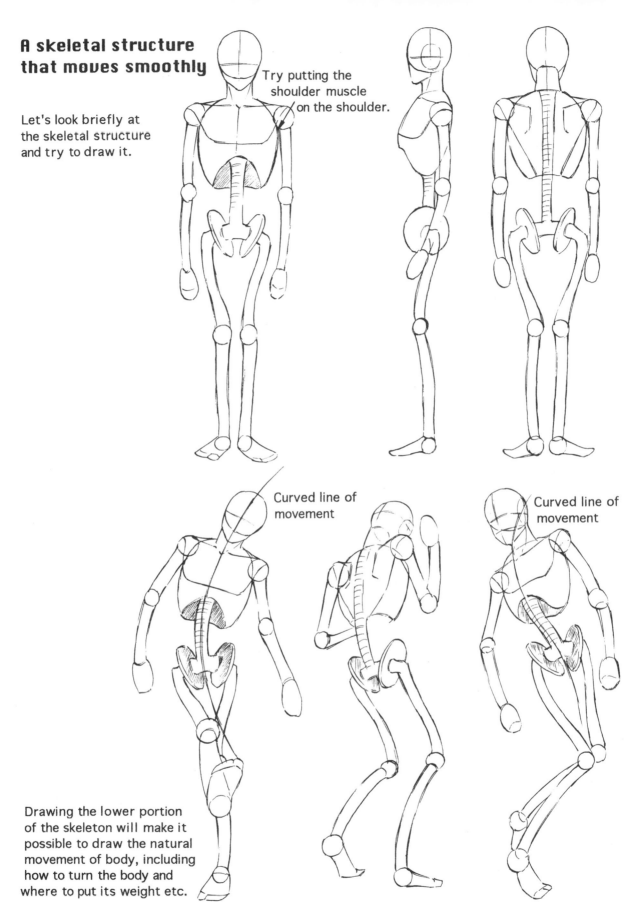

Try putting the shoulder muscle on the shoulder.

Curved line of movement

Curved line of movement

Drawing the lower portion of the skeleton will make it possible to draw the natural movement of body, including how to turn the body and where to put its weight etc.

Drawing in blocks

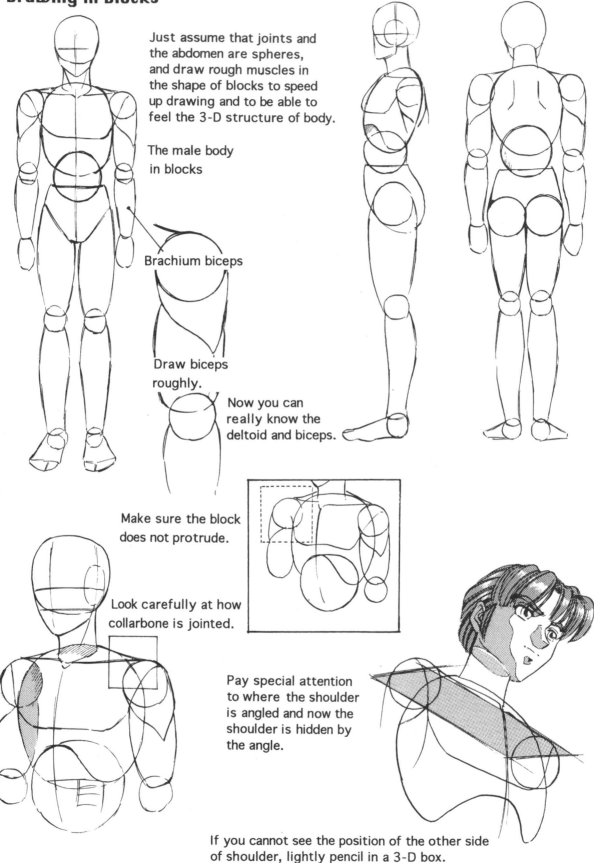

Just assume that joints and the abdomen are spheres, and draw rough muscles in the shape of blocks to speed up drawing and to be able to feel the 3-D structure of body.

The male body in blocks

Brachium biceps

Draw biceps roughly.

Now you can really know the deltoid and biceps.

Make sure the block does not protrude.

Look carefully at how collarbone is jointed.

Pay special attention to where the shoulder is angled and now the shoulder is hidden by the angle.

If you cannot see the position of the other side of shoulder, lightly pencil in a 3-D box.

The female body
in blocks

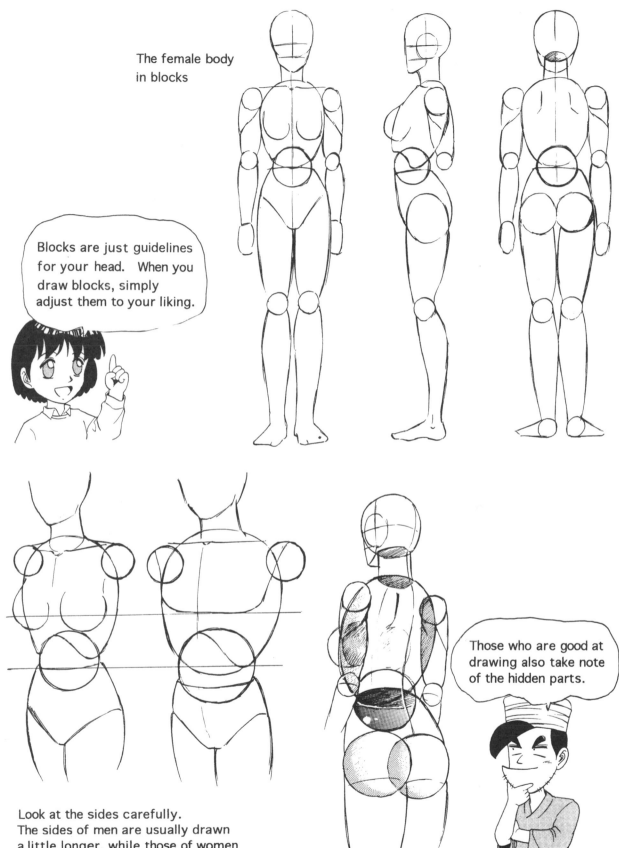

Blocks are just guidelines
for your head. When you
draw blocks, simply
adjust them to your liking.

Those who are good at
drawing also take note
of the hidden parts.

Look at the sides carefully.
The sides of men are usually drawn
a little longer, while those of women
are shorter and joint the hip almost
directly from the sternum.

Drawing movements

How to draw human body with the block method using the flow of the center line of the body and the curved line of movement.

The center line is the guideline for balancing the right and left sides of the body, and there are two lines one each for the front and the back.

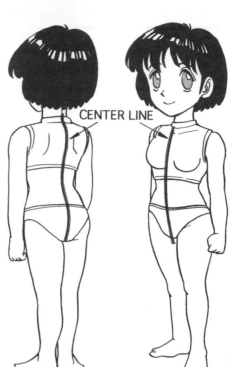

CENTER LINE

Place a center line on the visible side for a simple standing posture.

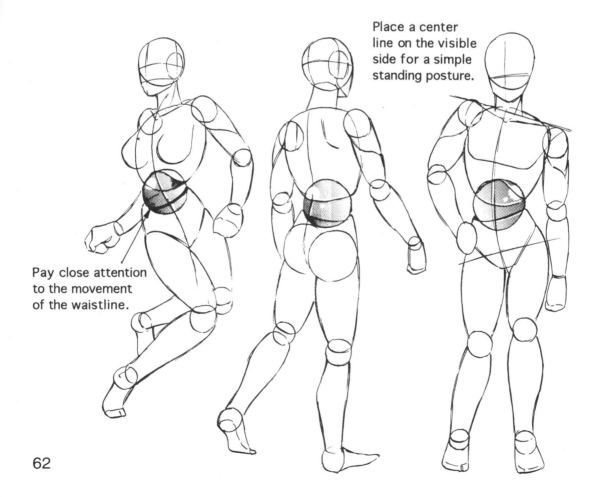

Pay close attention to the movement of the waistline.

Imagine a center line that goes with the flow of movement as sometimes the center line on visible side may be shrunk because of the back being bent and so on.

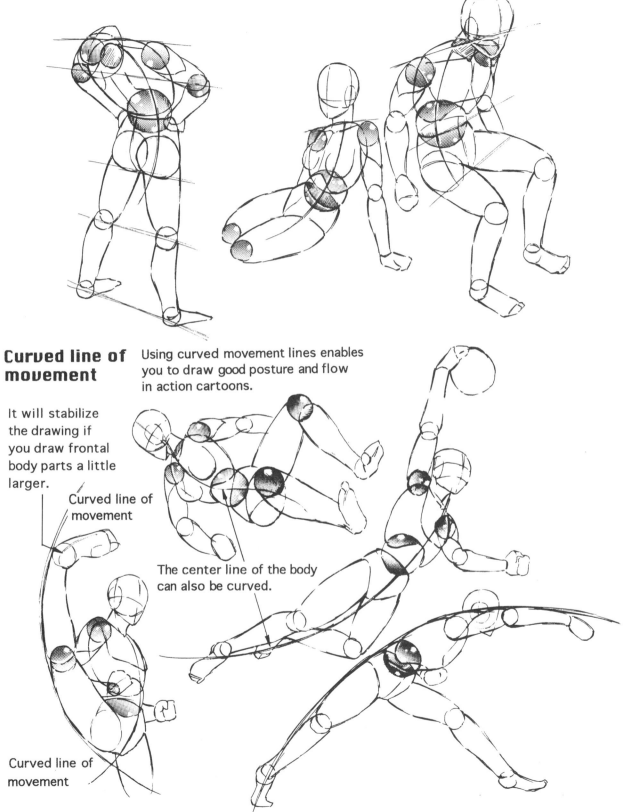

Curved line of movement

Using curved movement lines enables you to draw good posture and flow in action cartoons.

It will stabilize the drawing if you draw frontal body parts a little larger.

Curved line of movement

The center line of the body can also be curved.

Curved line of movement

DRAWING COMPLEX ANGLES

Quite a number of postures can be
drawn using the block method but you
may be able to do better if you use the
skeletal method for more complex angles.

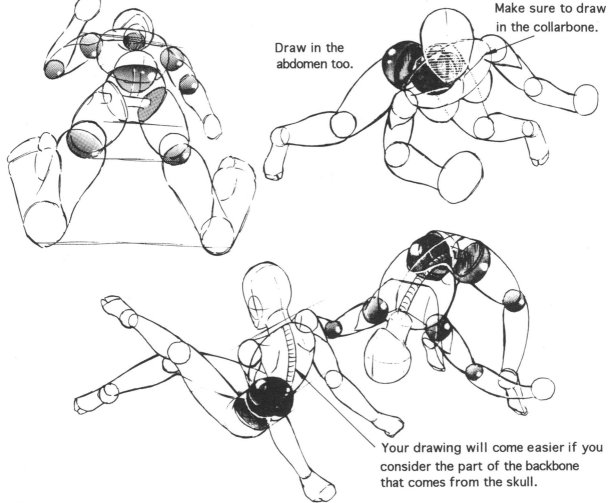

Make sure to draw
in the collarbone.

Draw in the
abdomen too.

Your drawing will come easier if you
consider the part of the backbone
that comes from the skull.

STANDARD HUMAN BODY STRUCTURE

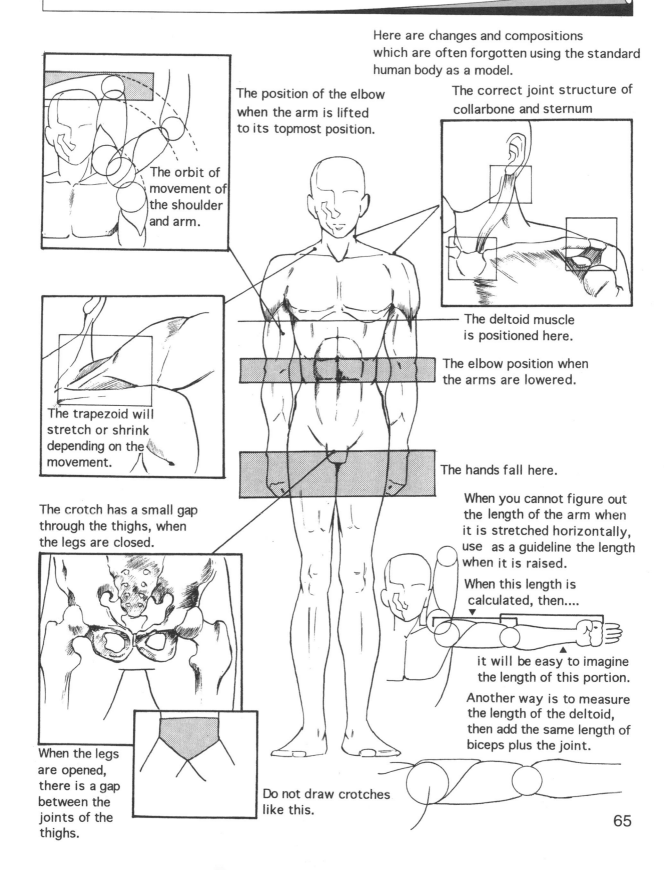

Here are changes and compositions which are often forgotten using the standard human body as a model.

The position of the elbow when the arm is lifted to its topmost position.

The correct joint structure of collarbone and sternum

The orbit of movement of the shoulder and arm.

The deltoid muscle is positioned here.

The trapezoid will stretch or shrink depending on the movement.

The elbow position when the arms are lowered.

The hands fall here.

The crotch has a small gap through the thighs, when the legs are closed.

When you cannot figure out the length of the arm when it is stretched horizontally, use as a guideline the length when it is raised.

When this length is calculated, then....

it will be easy to imagine the length of this portion.

Another way is to measure the length of the deltoid, then add the same length of biceps plus the joint.

When the legs are opened, there is a gap between the joints of the thighs.

Do not draw crotches like this.

Let's look at the back

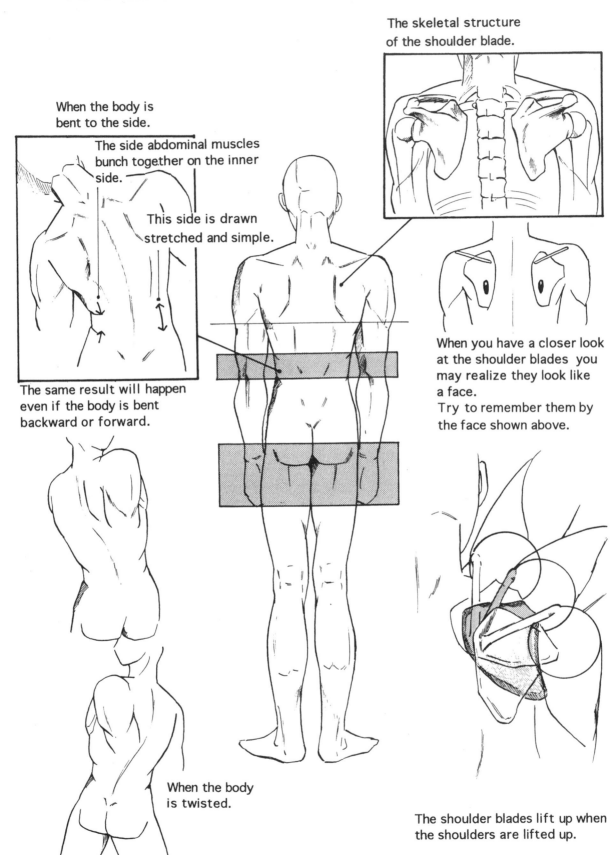

The skeletal structure of the shoulder blade.

When the body is bent to the side.

The side abdominal muscles bunch together on the inner side.

This side is drawn stretched and simple.

The same result will happen even if the body is bent backward or forward.

When you have a closer look at the shoulder blades you may realize they look like a face.
Try to remember them by the face shown above.

When the body is twisted.

The shoulder blades lift up when the shoulders are lifted up.

Let's look at the side

A guideline to standard hands and feet

The standard size of a hand is one big enough cover the face with it.

The shoulder may move back and forth a little.

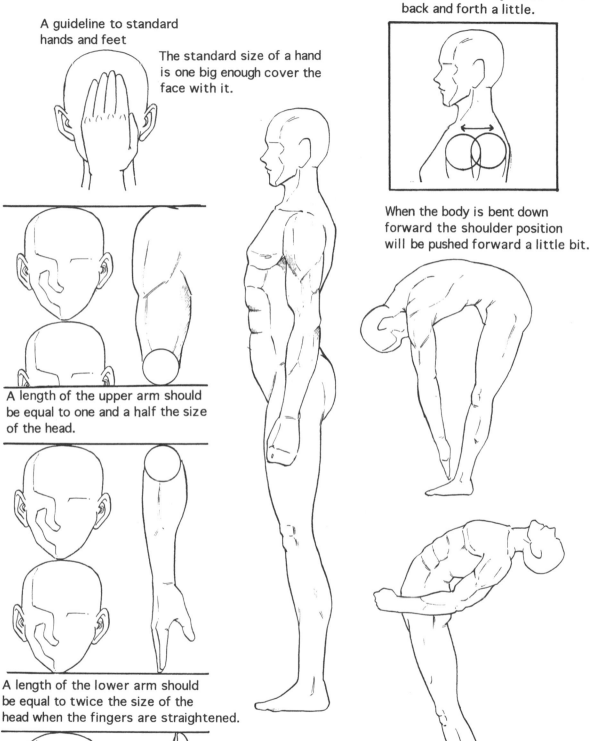

When the body is bent down forward the shoulder position will be pushed forward a little bit.

A length of the upper arm should be equal to one and a half the size of the head.

A length of the lower arm should be equal to twice the size of the head when the fingers are straightened.

On the other hand, when the chest is bent backwards, then the shoulder position will also fall backward a little.

The difference between the male body and the female body

Women usually have narrower
shoulders and the skeletal
structure around the breast
is smaller than for that of men.
The biggest difference is the
pelvis.

The woman's hipbone line
reaches to the navel and
the waistline comes above
navel.

The position of the nipples
is lower in women than in
men.

The upper position of the
hipbone reaches the navel
line.

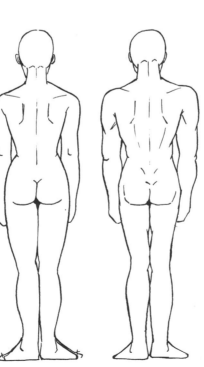

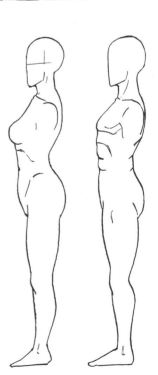

Men have the body shape
of a triangle in reverse,
while women have a wider
hipped body shape just like
a bowling pin.

Proportions

The proportion of the body is decided by the number of head lengths, so you should first ask yourself how many head lengths there are.

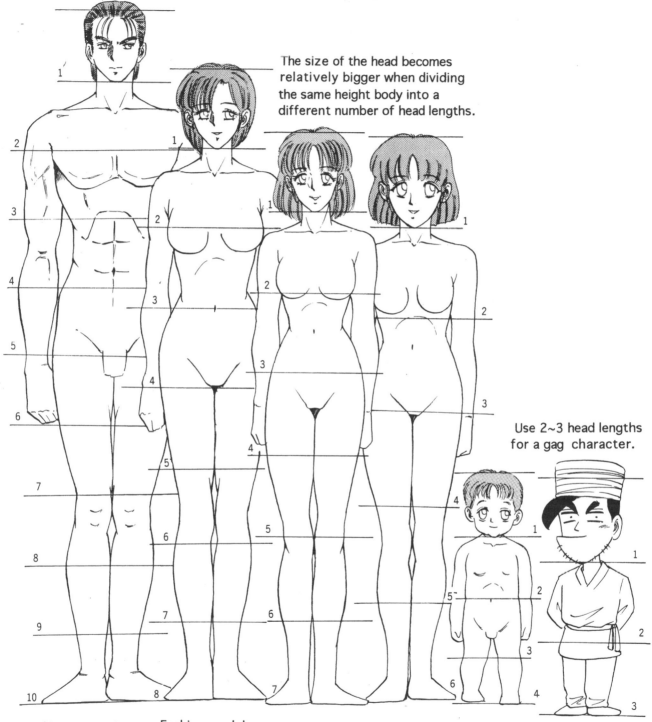

The size of the head becomes relatively bigger when dividing the same height body into a different number of head lengths.

Use 2~3 head lengths for a gag character.

Heroes are 9~10 head lengths tall.

Fashion models are 7~8 head lengths tall.

Use 6~7 head lengths for average adults.
Use 5~6 head lengths for old people.

Use 3~4 head lengths for toddlers.

DRAWING HANDS AND FEET

How to draw hands

Let's draw fingers using blocks.

Look at the gap, with fingers both closed and opened, of this part.

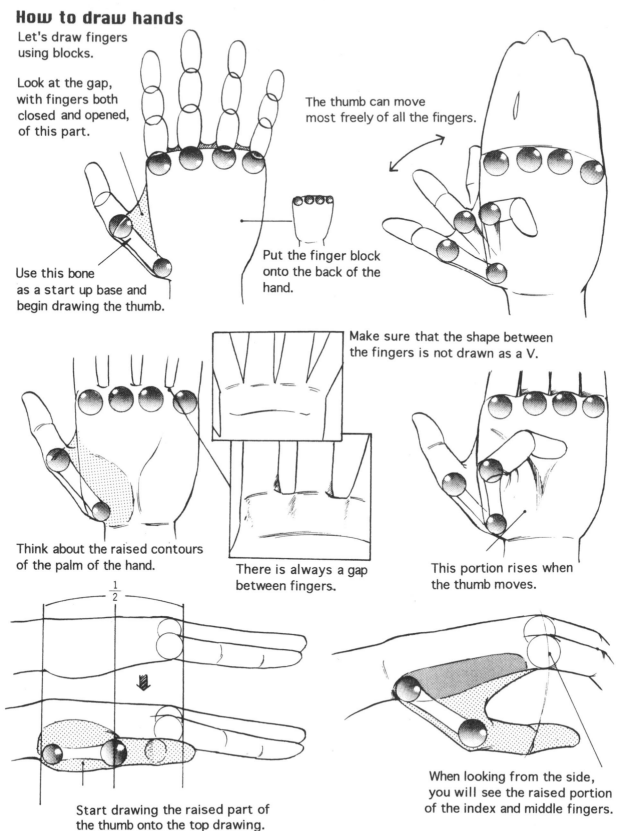

The thumb can move most freely of all the fingers.

Use this bone as a start up base and begin drawing the thumb.

Put the finger block onto the back of the hand.

Make sure that the shape between the fingers is not drawn as a V.

Think about the raised contours of the palm of the hand.

There is always a gap between fingers.

This portion rises when the thumb moves.

Start drawing the raised part of the thumb onto the top drawing.

When looking from the side, you will see the raised portion of the index and middle fingers.

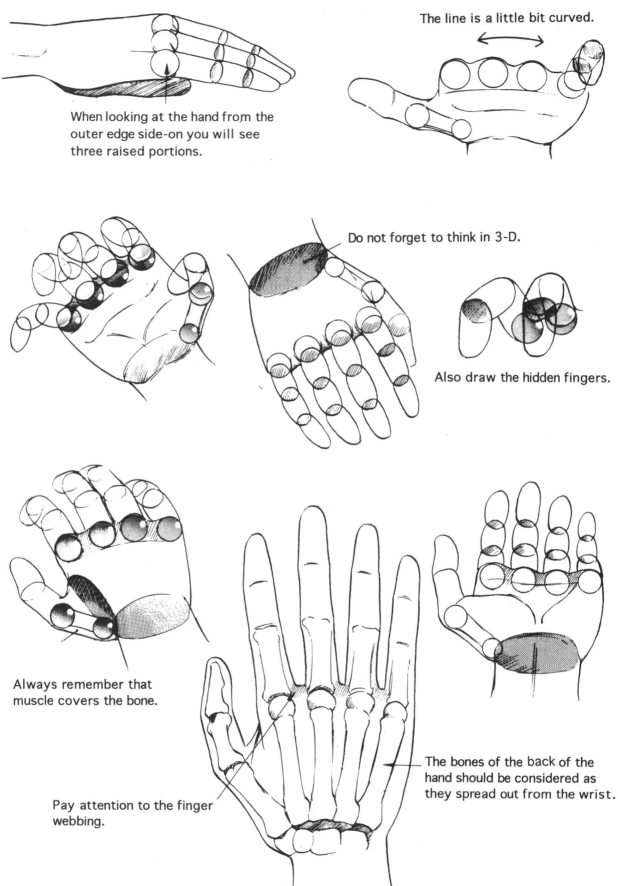

When looking at the hand from the outer edge side-on you will see three raised portions.

The line is a little bit curved.

Do not forget to think in 3-D.

Also draw the hidden fingers.

Always remember that muscle covers the bone.

Pay attention to the finger webbing.

The bones of the back of the hand should be considered as they spread out from the wrist.

Hands should look totally different depending upon how strongly the wrist is twisted and its angle. Sometimes you may not be able to work it out with just an image and theory.

In this case, look at your hand in the mirror and try to draw the theory out of the actual object.

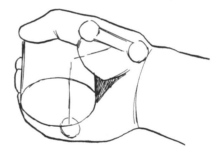

Consider the movements of the hand.

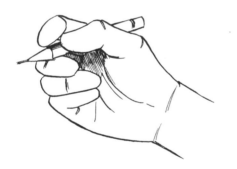

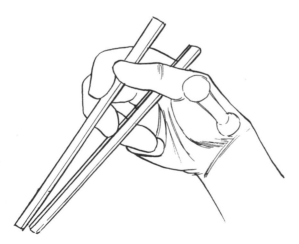

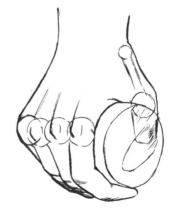

Draw feet

Draw feet in blocks, the same way as you draw hands.

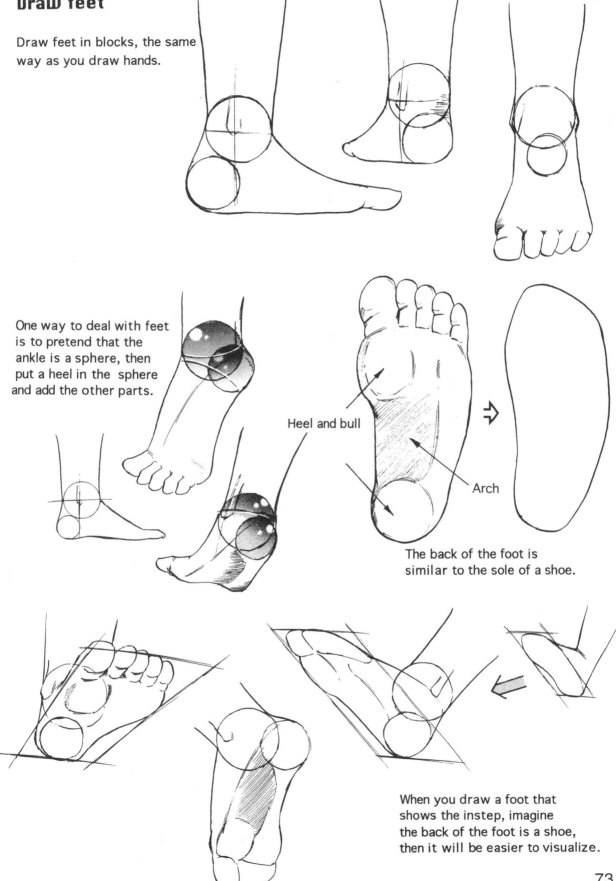

One way to deal with feet is to pretend that the ankle is a sphere, then put a heel in the sphere and add the other parts.

Heel and bull

Arch

The back of the foot is similar to the sole of a shoe.

When you draw a foot that shows the instep, imagine the back of the foot is a shoe, then it will be easier to visualize.

HOW TO DRAW FOLDS IN CLOTHES

Let's look at how clothes fall.

Here are the basics.

Folds are not elastic. However, they are formed because of forces from different angles, movements and gravity, etc.

Each garment will drape differently depending upon the material.

Figure A

You will be doing OK if it looks 3-D.

Direction of Force →

← Direction of Force

Even just a line for a wrinkle is a wrinkle.

If you want to add shadows to the folds, then think where the shade appears in the drape.

You can take it easy in cartoons. Basically, if you just capture the feeling, then it's fine.

Loose folds

When the fabric is pulled back.

This fold, as the figure shows, appears when the fabric overlaps. Wrinkles gather at the bent place.

Gravity causes this type of drape.

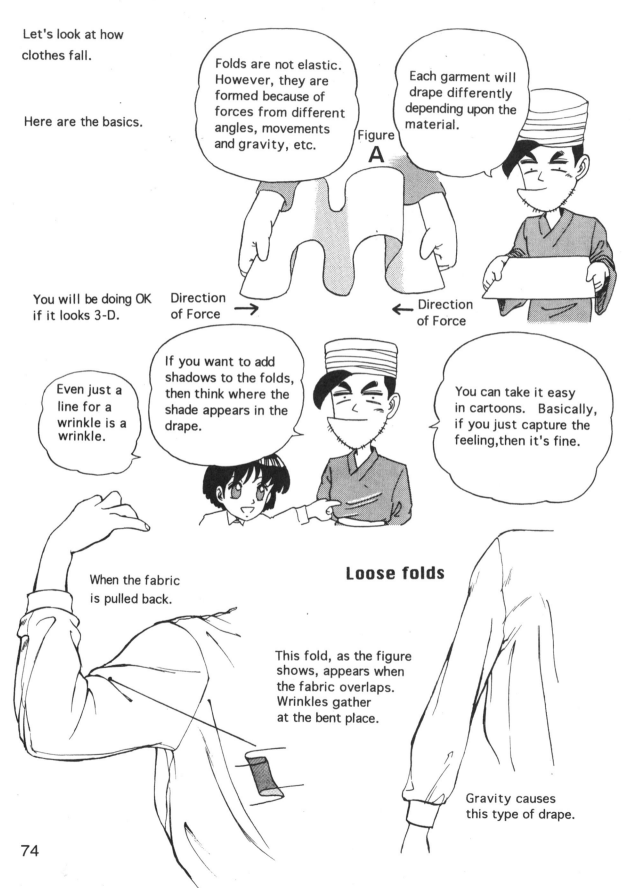

74

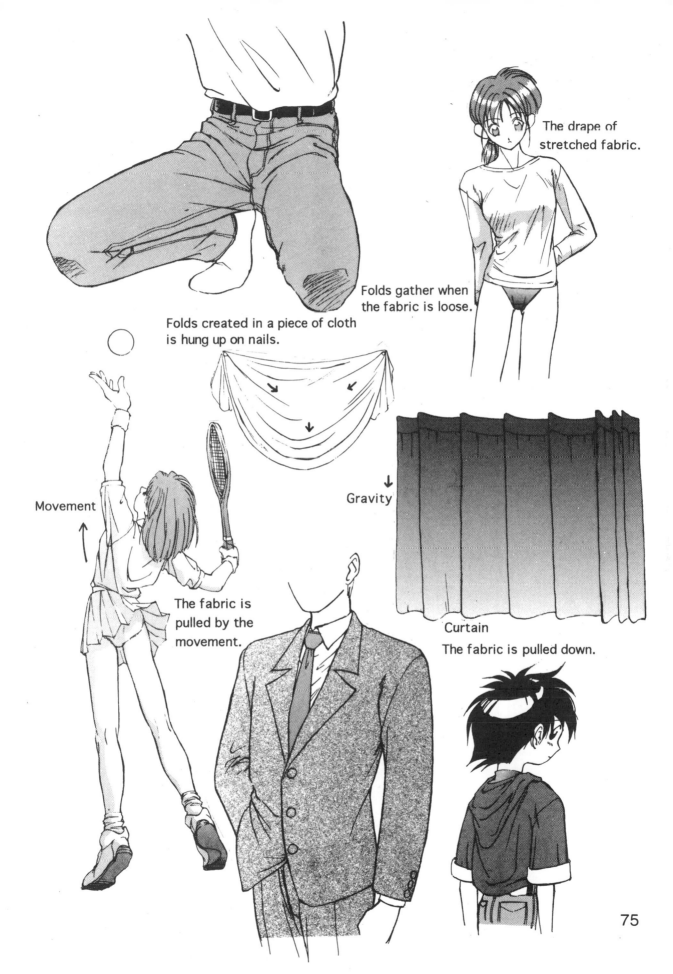

The drape of stretched fabric.

Folds gather when the fabric is loose.

Folds created in a piece of cloth is hung up on nails.

Movement

Gravity

The fabric is pulled by the movement.

Curtain

The fabric is pulled down.

75

Drawing a leather jacket

① First, draw a rough copy in pencil to decide where to position the shadows.

② When you finished drawing in the black color and the lines with pen, lay down the tone #63 (darkness 30%).

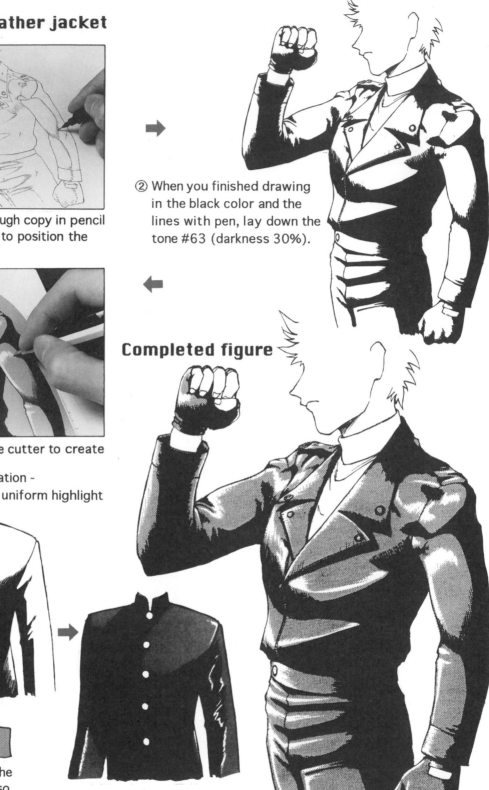

③ Rub out with the cutter to create shine.

Application - school uniform highlight

The light falls on the tops of the folds, so consider them carefully.

Completed figure

Basically, the 3-D effect comes from how light and shadow are used.
You can rub off to create highlights and also create borders.

Highlighting using a sand eraser

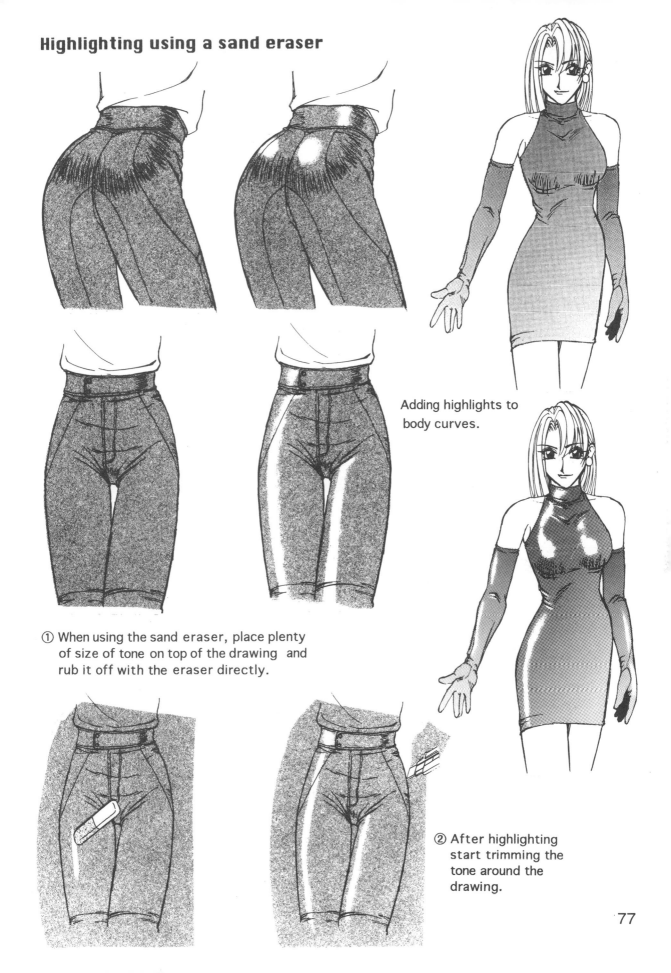

Adding highlights to body curves.

① When using the sand eraser, place plenty of size of tone on top of the drawing and rub it off with the eraser directly.

② After highlighting start trimming the tone around the drawing.

77

WHAT IS SHADOW IN MANGA?

Two kinds of shadows

There are two kinds of shadows in manga. One is the result of sunlight or illumination light.

The other is shadow to create a 3-D effect.

Second, we will try to draw shadows with a mixture of the two types, keeping in mind the direction of the light.

Let's start those shadows first.

Light and shadow are the key points for creating 3-D.

With objects that cast shadows you need to consider the direction from which the light comes, otherwise their use is irrelevant.

DEFORMATION OF THE BODY

What is a deformed body?

4~5 head lengths
(child style)

3 head lengths
(baby style)

Characters with short head legnths are drawn in gag cartoons.

It is the body shape deformed into babies and children.

The length of arm for babies is as short as for 3-head-length characters.

Hands and elbows will be positioned the same as for adults.

The arms of deformed characters will also look natural by drawing the length based on the body.

A raised arm will look strange if you use the adult arm length.

The most important point in manga

How does it look at first sight? Interesting? Cool? Cute? Beautiful? As long as it looks good at a glance, it will be quite acceptable even if your sketch is actually out of proportion.

By Yu Kinutani/Media Works/Dengeki Comics EX/from "Angel Arm"

79

Continued... What are deformed bodies?

Using perspective, near objects are drawn larger and those far away smaller.

Which figure do you think is more 3-dimensional?

When a fist is pushed forward, it looks like the Figure 1 in reality, but by deforming the perspective as in Figure 2, it will have greater dimensionality.

Figure 1　　　**Figure 2**

To create a sense of 3-D through deformation, draw the front larger and the near smaller. This is one of the basics of perspective. Objects drawn with some exaggeration is so called deformation, and it brings out a greater sense of space.

Far

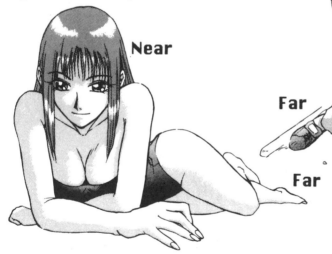

Near

Far

Far

Near

Perspective represented by far and near can be used not only for persons or characters but also for background.

Far

Near

THE BASICS OF DRAWING

What is sketching?

Sketching means to draw the object
in accordance with what you see.

When sketching you draw a rough copy first.
The rough copy is the base for the drawing to come.

When you draw a face, for example,
you look at the entire facial balance
and then decide the guidelines for positioning
the skeletal structure, eyes and nose.

After finishing the rough copy, you
work on the details. Making out the
shape means drawing a rough copy.

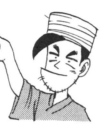

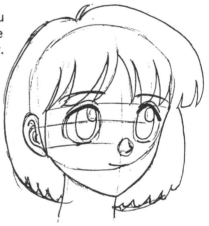

If you start working on the details
first, it will be difficult to look at
the entire balance, and you may take
a long time to adjust it.

It is same for not only
faces and bodies, but
also for the background.

This is the basis
of drawing.

Is this Picasso
or what!

What is manga?

It means to sketch the image in your mind.

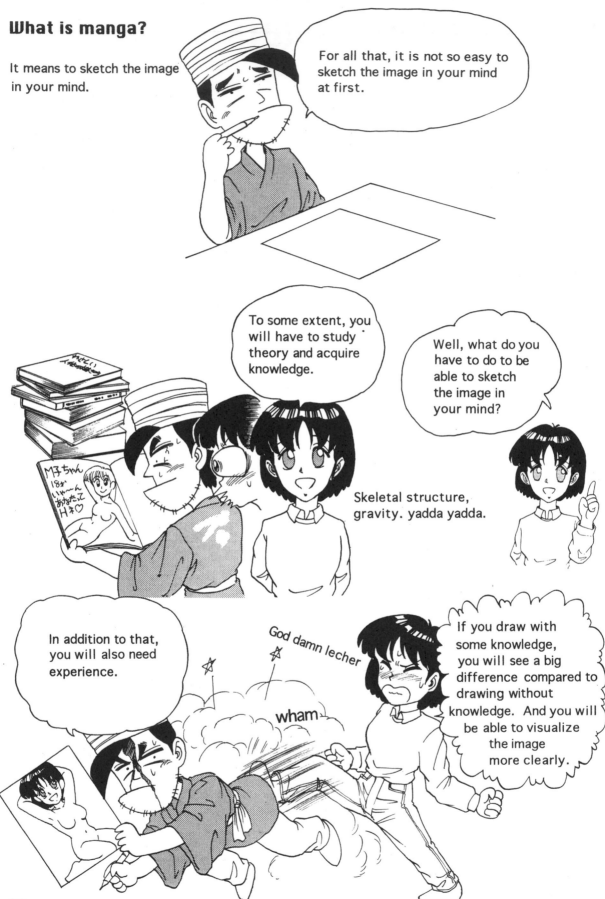

For all that, it is not so easy to sketch the image in your mind at first.

To some extent, you will have to study theory and acquire knowledge.

Well, what do you have to do to be able to sketch the image in your mind?

Skeletal structure, gravity. yadda yadda.

In addition to that, you will also need experience.

God damn lecher

wham

If you draw with some knowledge, you will see a big difference compared to drawing without knowledge. And you will be able to visualize the image more clearly.

Sketching nudes

You may not have a model for drawing, so look at photo collections, etc. and sketch.

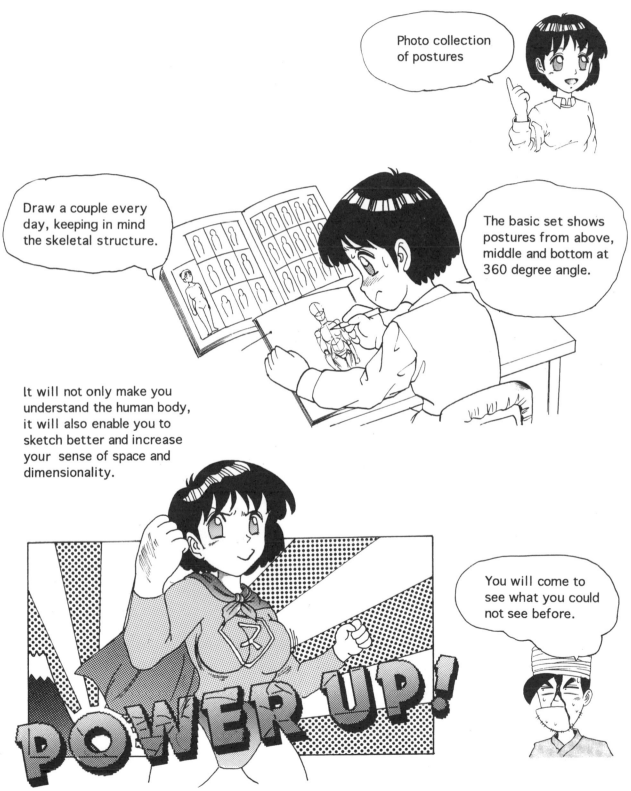

Photo collection of postures

Draw a couple every day, keeping in mind the skeletal structure.

The basic set shows postures from above, middle and bottom at 360 degree angle.

It will not only make you understand the human body, it will also enable you to sketch better and increase your sense of space and dimensionality.

POWER UP!

You will come to see what you could not see before.

SUMMARY

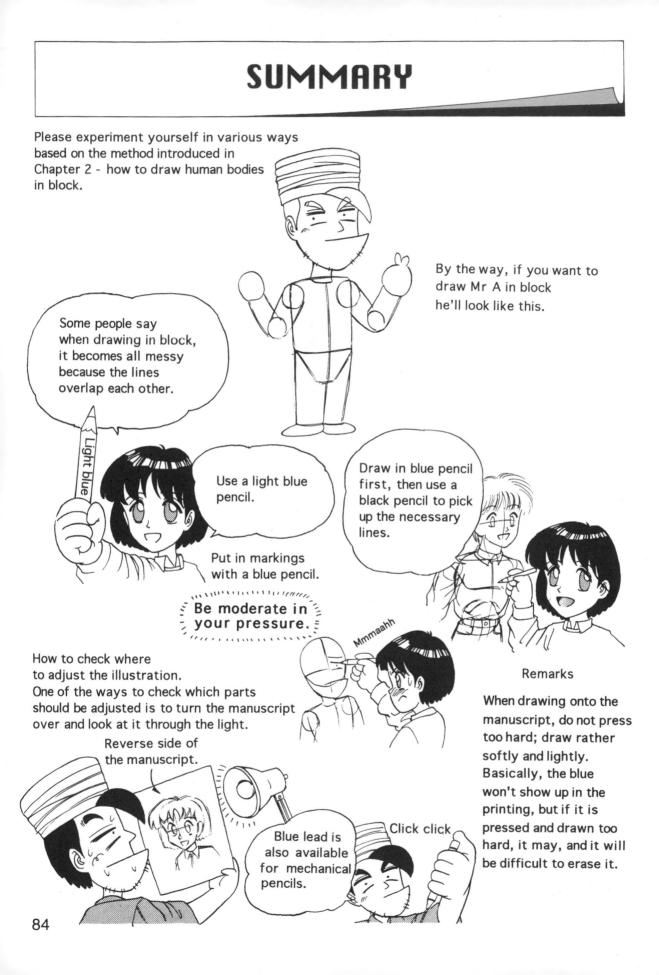

Please experiment yourself in various ways based on the method introduced in Chapter 2 - how to draw human bodies in block.

By the way, if you want to draw Mr A in block he'll look like this.

Some people say when drawing in block, it becomes all messy because the lines overlap each other.

Use a light blue pencil.

Put in markings with a blue pencil.

Light blue

Draw in blue pencil first, then use a black pencil to pick up the necessary lines.

Be moderate in your pressure.

How to check where to adjust the illustration. One of the ways to check which parts should be adjusted is to turn the manuscript over and look at it through the light.

Reverse side of the manuscript.

Mmmaahh

Remarks

When drawing onto the manuscript, do not press too hard; draw rather softly and lightly. Basically, the blue won't show up in the printing, but if it is pressed and drawn too hard, it may, and it will be difficult to erase it.

Blue lead is also available for mechanical pencils.

Click click

84

CHAPTER 3
DRAWING CHARACTERS

THE THREE MAJOR ELEMENTS OF MANGA

What does the theme mean?

The three major elements in drawing manga are THEME, STORY and CHARACTER.

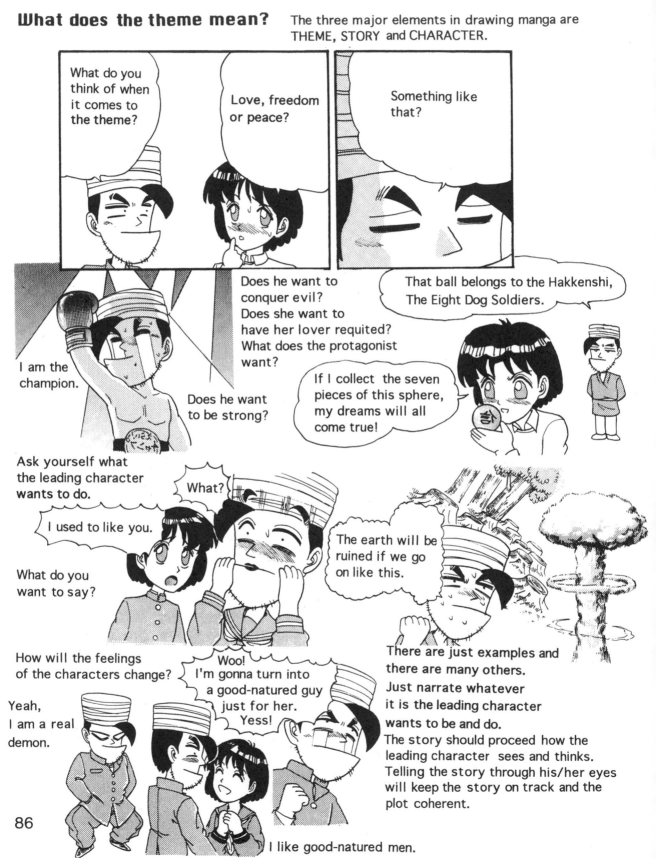

What do you think of when it comes to the theme?

Love, freedom or peace?

Something like that?

I am the champion.

Does he want to conquer evil?
Does she want to have her lover requited?
What does the protagonist want?

Does he want to be strong?

That ball belongs to the Hakkenshi, The Eight Dog Soldiers.

If I collect the seven pieces of this sphere, my dreams will all come true!

Ask yourself what the leading character **wants to do.**

What?

I used to like you.

What do you want to say?

The earth will be ruined if we go on like this.

How will the feelings of the characters change?

Woo! I'm gonna turn into a good-natured guy just for her. Yess!

Yeah, I am a real demon.

There are just examples and there are many others.
Just narrate whatever it is the leading character wants to be and do.
The story should proceed how the leading character sees and thinks.
Telling the story through his/her eyes will keep the story on track and the plot coherent.

I like good-natured men.

86

What does story mean?

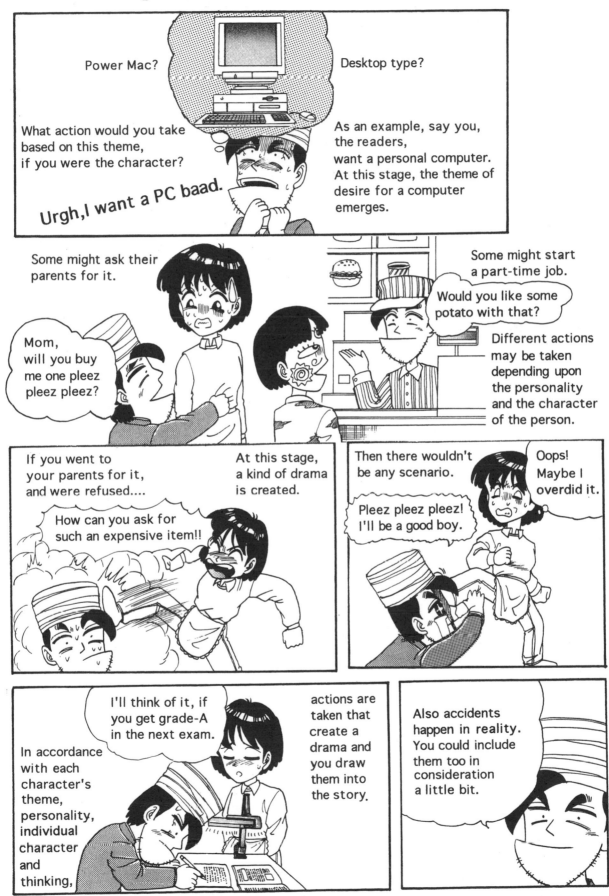

Power Mac?

Desktop type?

What action would you take based on this theme, if you were the character?

As an example, say you, the readers, want a personal computer. At this stage, the theme of desire for a computer emerges.

Urgh, I want a PC baad.

Some might ask their parents for it.

Some might start a part-time job.

Would you like some potato with that?

Mom, will you buy me one pleez pleez pleez?

Different actions may be taken depending upon the personality and the character of the person.

If you went to your parents for it, and were refused....

At this stage, a kind of drama is created.

How can you ask for such an expensive item!!

Then there wouldn't be any scenario.

Oops! Maybe I overdid it.

Pleez pleez pleez! I'll be a good boy.

I'll think of it, if you get grade-A in the next exam.

In accordance with each character's theme, personality, individual character and thinking,

actions are taken that create a drama and you draw them into the story.

Also accidents happen in reality. You could include them too in consideration a little bit.

You must follow the basics when creating a story.

The introduction, development, climax and conclusion

What do these terms mean?
First, fit the theme of the leading character into its genre - he wants the girl he likes to become his girlfriend. The genre is the so called love-come - short for Love Comedy.
It is a love manga with a touch of comedy.

yap
yap

pant
pant

However, this protagonist has a strong aversion to dogs.

This leading character has someone he secretly likes.

Development

The story keeps develop.

Maybe this development is too abrupt.

I like you! Please date me!

What's with you, buddy!

However, she loves dogs and bulldogs best of all. Maybe she is not scared by his face.

Introduction

At this stage, you introduce the reader to the manga world, set up the situation and location, begin the story there.

Let readers know who the leading character is at this start-up stage. This leading character is a man of large frame with a fierce-looking face, and everybody is scared of him.

Only she is not scared of me.

Morning!

Hi!

At the introduction stage, you show the situation and a certain degree of the personality of the leading character, including the issue "why he likes her".

She says she cannot get along with a man who does not like dogs, and he was rebuffed.

Crazy!

Turning point

The story develops in different directions and at some point there will be reversal of events, and for a climax.

The leading character was rebuffed; however, he will confirm to act in accordance with the theme.

There's the special training he formulated to overcome his fear of dogs.

Woo-oo

Urgh ugh....

yap yap....

BIG IRON SPHERE

Once again, he decides to go see her.

OKAY-GO
GO GO

If I don't make her my girl I'll never be able to get any girl, ever!

Finally, he shows the result of his special training.

Denouement

This is the stage when the results begin to play out, i.e. the conclusion. Something may change at the end or there happens a progress.

Well, let's start by being friends.

Yess!

We wish to see efforts go rewarded.

The leading character has become somewhat accustomed to dogs, but he is still scared basically.

Isn't she cute?

We sometimes include these "games" so that readers can go away with a good impression.

You're really giving him, aren't you.

Yeooww

Argh!

The most important point when creating a story

You might have worked very hard to come up with a manga, but it will be in vain unless the story is understood by the readers.
The most important point in creating a story, therefore, is to make it easy to understand. To do so, you have to make it easy to read...

WHEN (time)
WHERE (place)
WHO
WHAT is done or being done

And you must make it clear how and why it turned out that way.

> I like you.
> Please date me!

What is happening now is related to the past, and will affect conclusion.

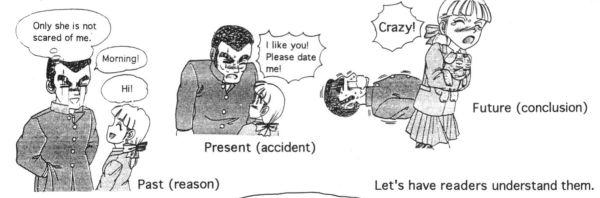

> Only she is not scared of me.

> Morning!

> Hi!

Past (reason)

> I like you! Please date me!

Present (accident)

> Crazy!

Future (conclusion)

Let's have readers understand them.

```
         ┌── Who
         ├── When (time)
5Ws ─────┼── Where (place)
         ├── What (done)
         └── Why (Why it turned out so)
```

> There are still several other issues, such as composition and so on, but on this page, we will only touch on the basic.

1H How (What was done and how it turned out)
Always remember the 5Ws and 1H.

What is character?

The most important elements of manga are the characters. Both the theme and the past story are carried by the character.

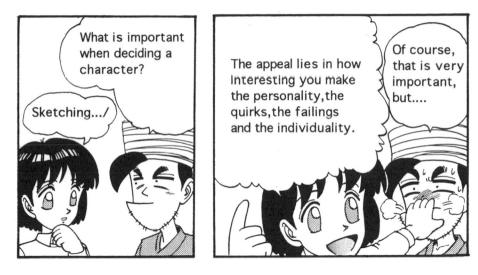

> What is important when deciding a character?

> Sketching.../

> The appeal lies in how interesting you make the personality, the quirks, the failings and the individuality.

> Of course, that is very important, but....

An interesting work has above all, a strong main character, who lives vividly within the story. Even though readers may not remember the story the character lives on in them.

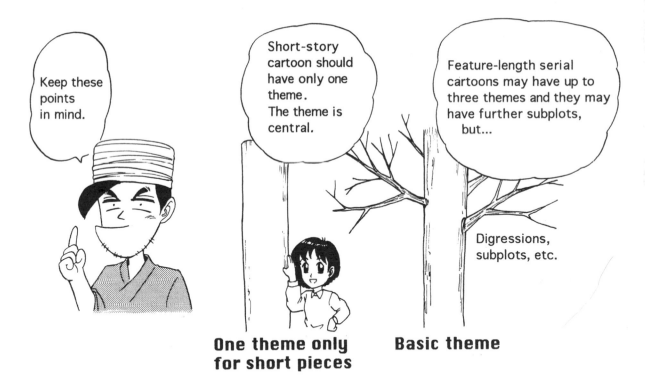

> Keep these points in mind.

> Short-story cartoon should have only one theme.
> The theme is central.

> Feature-length serial cartoons may have up to three themes and they may have further subplots, but...

> Digressions, subplots, etc.

One theme only for short pieces

Basic theme

Antagonists and supporting casts are important!

Assuming that there is a hero, as in the example.

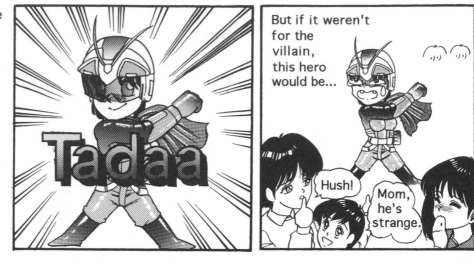

But if it weren't for the villain, this hero would be...

Hush!

Mom, he's strange.

Express his character and shine.

Only when there is villain, can a hero

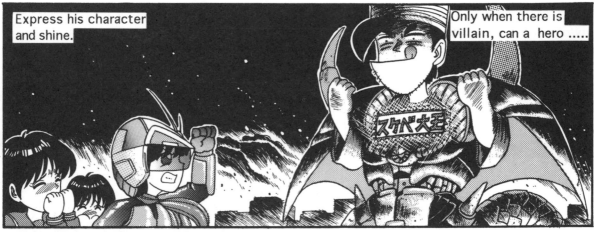

Grrrrr

ACHOO!

Heh..

Some basic examples are :
When you draw a cold antagonist vs a passionate hero, their mutual personalities, coldheartedness and passion will each clearly bring out the other's character.

However, it will be a little difficult if the hero and the antihero have the same character, unless both of them have passion. When both of them have just ordinary characters, it will be difficult for them to play off one another, and you run the risk of a story that just goes through the paces.

And one more example, this time of a love comedy.
If the leading boy and girl are both shy and cannot say around that they like the other, the story will not develop and there will be no sense of character.

But if a rival with a positive presence shows up, it will bring out the characters of the protagonists, and as a result, the story will develop.

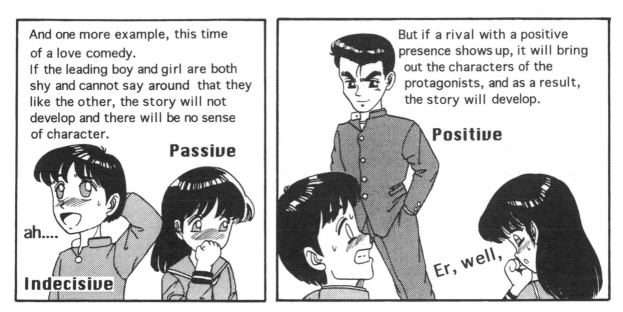

The antagonist and supporting cast are very important in creating and showcasing the leading character.

In manga, it is important to think about the personalities of characters. Even with theme alone, a story will follow.
This is the secret fundamental to manga.

Individuality and personality are created from how the characters interact.

ACTUAL TONES

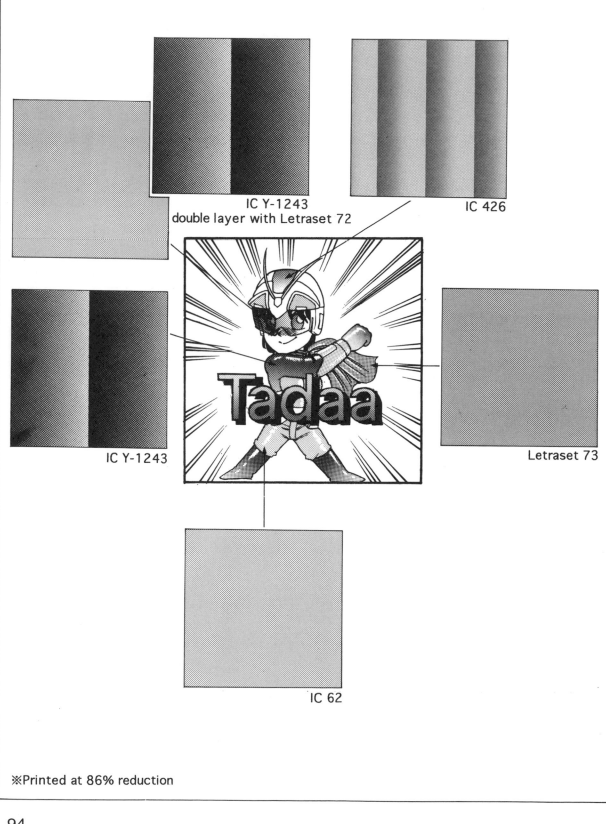

IC Y-1243
double layer with Letraset 72

IC 426

IC Y-1243

Tadaa

Letraset 73

IC 62

※Printed at 86% reduction

LET'S CREATE CHARACTERS

Considering individuality and personality
decide the genre first.

Then decide the look of the character
and think about his profile.
Now start using your imagination.

Something like this?

Write down the traits of the
character to bring out the
interesting points, and
illustrate the character in
different poses to realize
him more strongly.

I am a serious
student.

AGE 16 if so, a student ⇨ if so, the plot must be set at school.

CHARACTERISTICS	Quarreling	if so, strong body ⇨ likes to be active ⇨ if so, be good at studying.
DISLIKES (Weak point)	Studying/Dogs	A man with a fearsome face, likes quarreling, is afraid of dogs. This may be an interesting point to develop.
LIKES (Words or phrases etc.)	Special training	If so, he applies special training to every occasion. Personality like hot geyser dispenser ⇨ blood type B?
Individual feature	Large frame, fearsome face Very good at picking a fight, hangs round with rowdies.	
Character	Blood type B, so can do only one thing at a time. Easily interested and motivated!	

◎ Maybe he doesn't think of himself
 as a rowdy??
◎ The genre is Love Comedy and
 the theme is "I want you to be
 my girl."
◎ What type is his type?
◎ Why he comes to like her?

yap yap

pant
pant

Sometimes you may imagine it from the other end and find the main character from the supporting characters. Needless to say, you may also imagine it first from the personal profile, etc.

When you come up with the central personalities in the story, think about the kind of antagonist you think will be able to play against them.

When you have come up with that character, imagine and develop the story based on explanation or page [What does story mean?] .

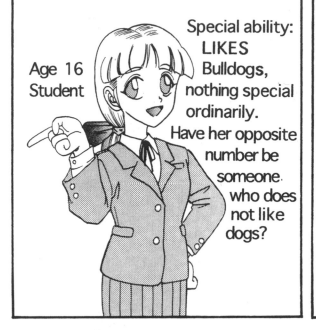

Age 16
Student

Special ability:
LIKES
Bulldogs,
nothing special
ordinarily.
Have her opposite
number be
someone.
who does
not like
dogs?

It's also a good idea to find and create a character from the people around you.

Also, try to look at yourself objectively.

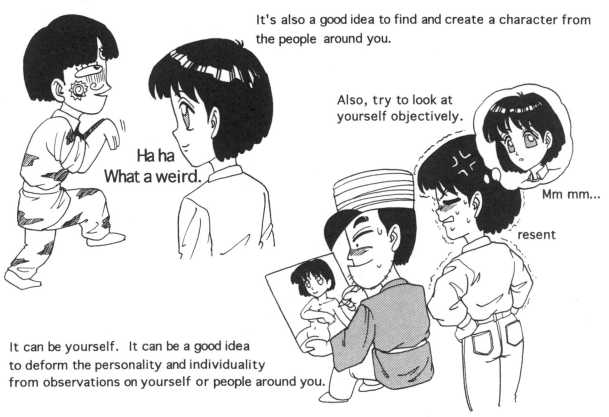

Ha ha
What a weird.

Mm mm...

resent

It can be yourself. It can be a good idea to deform the personality and individuality from observations on yourself or people around you.

Character created by the story

Some decide to draw cartoons because a story, set-up, incident, or interesting situation occurred to them.

In this case, jot down a rough outline of the incident and its cause in a notebook for the portion you want to describe.

Make up a plot. When you make up a plot, then different thoughts will emerge.

You might come up with a wonderful scenario, or glamorous situation. Then, create a character suitable for that situation.

If the manga you are working on is a short piece of 31 pages, then you may want to create a great protagonist using all 31 pages.

While you are developing the character, you may refine the plot again through the feelings of the character, inserting some lines as you go.
Go back to the "What is story?" chapter.

PRODUCING THE CHARACTER

The first impression comes mostly from the face. For example, a person with droopy eyes or lifted eyes will give different impressions.

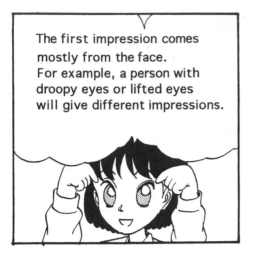

In addition to physiognomy, the shape of the eyebrow and the height of the nose etc. all affect your impression. Now I put that concept to work and create some characters.

Character with a strong will

◎ Image of a hard worker
◎ Strength of will is most strongly represented by the eyebrows. They should be firm and the ends should lift up.
◎ Mouth is firmly closed; Reversed V shape
◎ In case of girls, they may have short hair so that they can or maybe they tie up their hair into a bun.

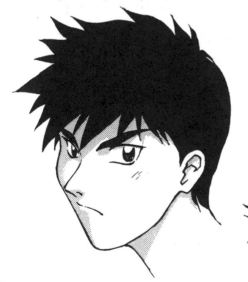

The drawing right shows a supporting characters but his eyebrows and the impression of his mouth alone represent the strength of his will.

Rather cool types

◎ Cool types come in different kinds—
 there is the artistic type, the cruel
 type, the delicate type and the calm
 of noble pride type.
◎ Narrow eyebrows feminize the character
 and give a sense of delicacy.
◎ Long, sharp eyes give a sense of beauty.
◎ Clear nose line. It is often said that
 those who have high bridges also have a
 lot of pride.
◎ Skeletal structure is
 somewhat slender.
◎ Hair is parted in proportions
 of 3 to 7, the typical hair
 style of a gifted man.

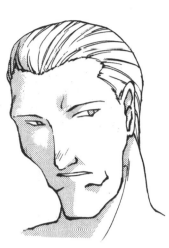

Eyeglasses are sometimes used
as props but the shape of the
spectacles may affect the
image of the character. So
please study this yourself.

The wild type

◎ The wild type is a very masculine
 image, quite the opposite of the
 calm, intelligent type.

 This type does not care about
 appearance, minor matters or
 small things.
 ◎ The wild guy has a large
 build. You can produce a
 strong skeletal structure
 by drawing the lower jaw
 firmly.
 ◎ When the mouth is
 drawn large, it gives
 the impression of
 wildness that does not
 care about minor
 details.
 On the other hand, a smaller
 mouth looks more feminine.

◎ This type does not care about
 hair either, so you may create
 something unconventional.

An intelligent wild guy
would be pretty cool.

99

Type of character who is cute and perky

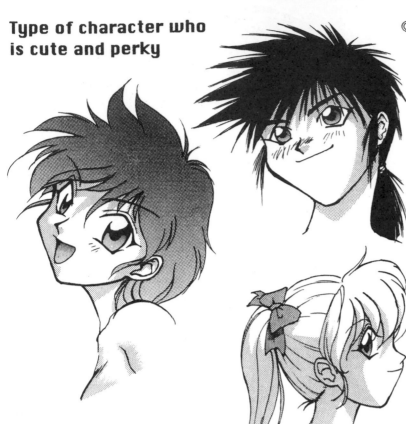

◎ Someone perky, someone active has short hair or tied back hair, suits this character.
◎ Eyes should be wide open.
◎ Facial proportions should be closer to those for children.
◎ If the nose is drawn a little smaller, it will look cute.
◎ You should use as great a variety of expressions as possible.
◎ Use ribbons as a decorative item, for props.

The gentle type

◎ Always keep smiles.
◎ When the eyebrows are close and together it gives a strong impression; if they are widely spaced, it creates a sense of softness.
◎ Narrow, droopy eyes convey gentleness.
◎ Long hair conveys calm and intelligence.
◎ Round faces also produce a sense of calmness.

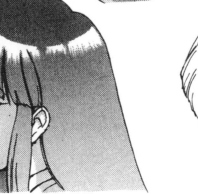

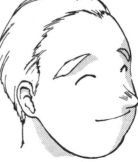

Weak-willed characters

◎ These types are more delicate than beautiful.

◎ When the calm of the gentle type is drawn differently it becomes this weak type.

◎ Needless to say, to keep it smiling, this type will have an impression of being troubled or lack of confidence in the face.

◎ A troubled feeling or lack of confidence is also conveyed by the hair, which should be self-effacing.

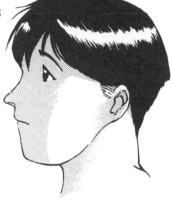

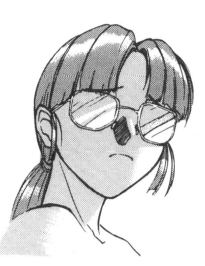

Strong willed and selfish

◎ This character looks strong willed, with a lot of pride, like a young woman who has grown up spoiled.

◎ The eyes are slightly up lifted and fox-like eyes. This type is easy to produce.

◎ The princess type should have gorgeous curled hair.

◎ To portray an active woman different to the spoiled princess look, add a suntan.

Villains

◎ As an image, the eyes are triangular and most of the eye is white. Fox eyes convey a sense of cunning.

◎ A bold head and/or a face without eyebrows gives a sinister feeling.

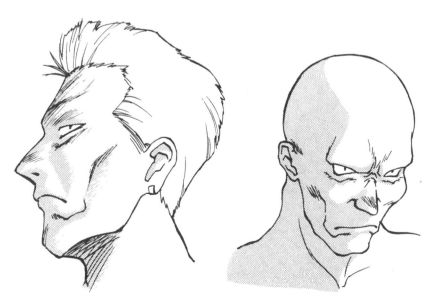

The shape of the body is also character

Different body shapes carry their own images, such as...
A tall person does not look able to move quickly.
On the other hand, a small person looks very agile.
The image of a fat person doesn't go with a sense of sports, etc.
Using those images, convert them into the personality of the character.
You may take reverse advantage of those images and create
a character who is fat but agile.

In hand-to-hand fighting manga,
sports manga and/or action manga,
the body shape may be weak and a
drama sometimes is made out of that.

When you draw sports manga,
please study body shapes seriously.

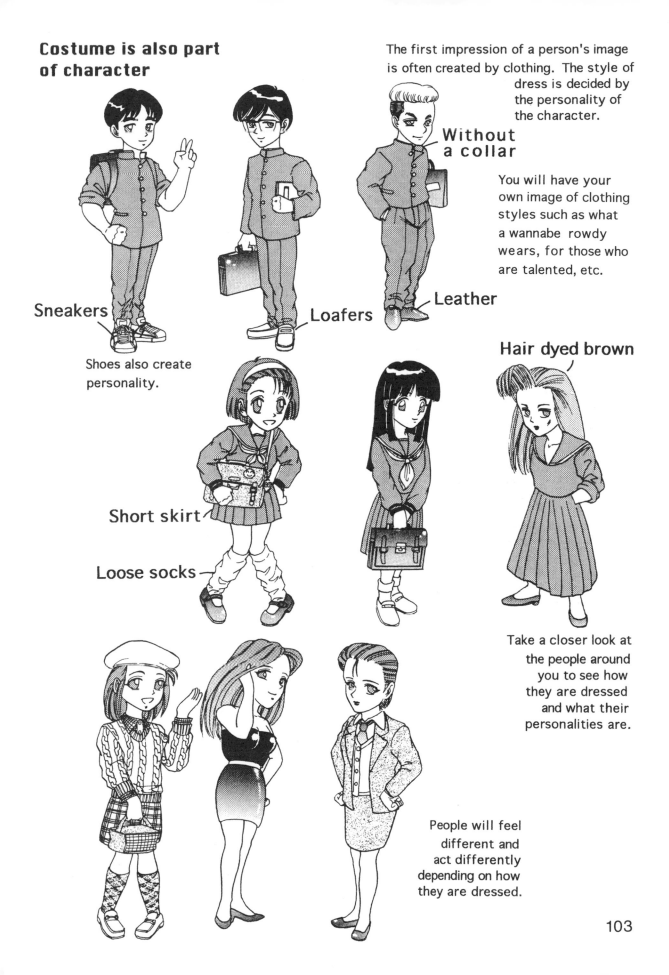

Costume is also part of character

The first impression of a person's image is often created by clothing. The style of dress is decided by the personality of the character.

Without a collar

You will have your own image of clothing styles such as what a wannabe rowdy wears, for those who are talented, etc.

Sneakers

Loafers

Leather

Shoes also create personality.

Hair dyed brown

Short skirt

Loose socks

Take a closer look at the people around you to see how they are dressed and what their personalities are.

People will feel different and act differently depending on how they are dressed.

Accessories to the characters

The manner of speaking, the movement of the body, possessions, room interiors etc. all have their own characteristics and can become characters in themselves too.

Well,I.....

Well,I.....

Well,I.....

Just by listening to the manner of speaking, you will be able not only to imagine how a character was brought up, but also to imagine its personality. For example, you will imagine that those young girls who call themselves "boku", the male word for "I," must have been brought up among brothers only, and she has become boyish and openhearted.

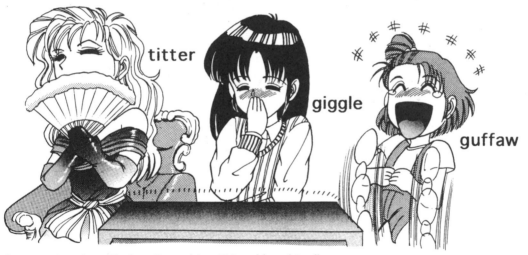

titter

giggle

guffaw

When a scenario calls for "watching TV and laughing" you realize that there are different kinds of laughter.

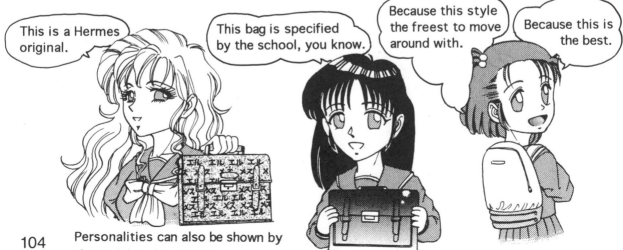

This is a Hermes original.

This bag is specified by the school, you know.

Because this style the freest to move around with.

Because this is the best.

Personalities can also be shown by the articles they carry.

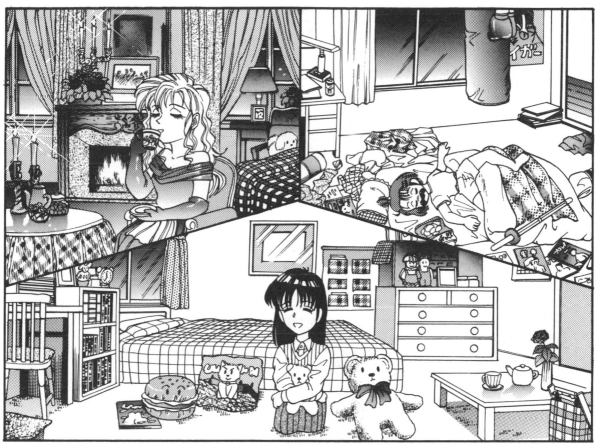

Personalities will also express themselves in their surroundings, their possessions and how they are placed. You will be able to imagine that those who are lazy and sloppy in their dress will also be live in a messy room.

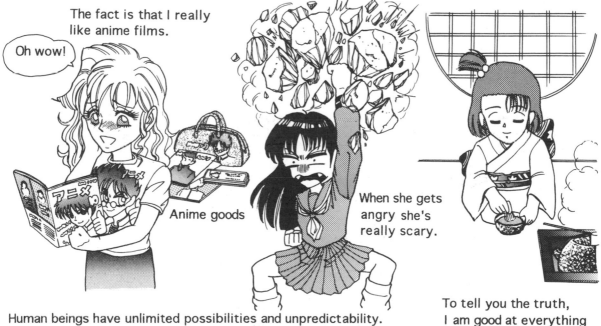

The fact is that I really like anime films.

Oh wow!

Anime goods

When she gets angry she's really scary.

To tell you the truth, I am good at everything like ikebana, tea ceremony, and cooking.

Human beings have unlimited possibilities and unpredictability. That can be a weak point and it is also positive. It makes characters more humanlike. Think about those aspects that cannot be unanticipated.

How to draw out emotion

Emotion shows up not only in the face but also in the body. Consider how to express emotion in your work, considering the feeling at that time.

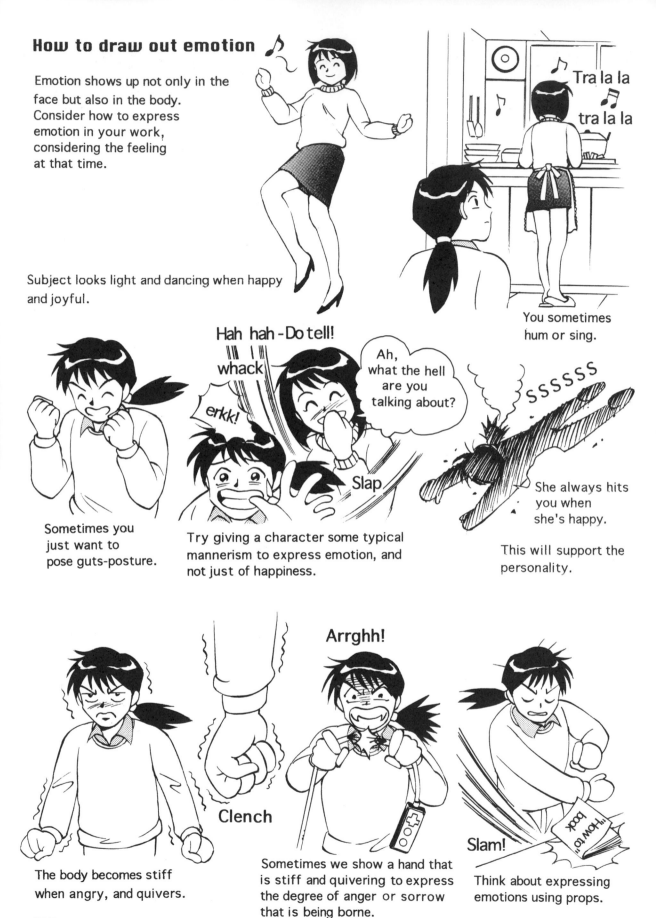

Subject looks light and dancing when happy and joyful.

You sometimes hum or sing.

Hah hah - Do tell!

whack

erkk!

Ah, what the hell are you talking about?

Slap

Sometimes you just want to pose guts-posture.

Try giving a character some typical mannerism to express emotion, and not just of happiness.

She always hits you when she's happy.

This will support the personality.

Arrghh!

Clench

The body becomes stiff when angry, and quivers.

Sometimes we show a hand that is stiff and quivering to express the degree of anger or sorrow that is being borne.

Slam!

Think about expressing emotions using props.

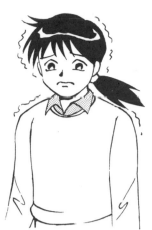

When she is feeling sad, loses strength.

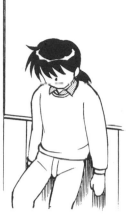

She is in low spirits and wants to lean against something for support.

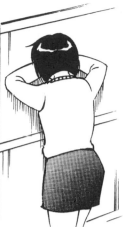

Or face the wall.

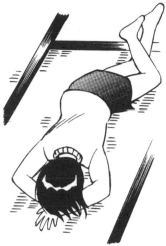

Or lie on the floor and cry.

The body freezes when surprised.

The body will shrink when tense or frightened.

Gulp

Zooming up on the faltering feet is also very effective.

To show contempt draw the figure from below. It gives the figure the proper look of disdain.

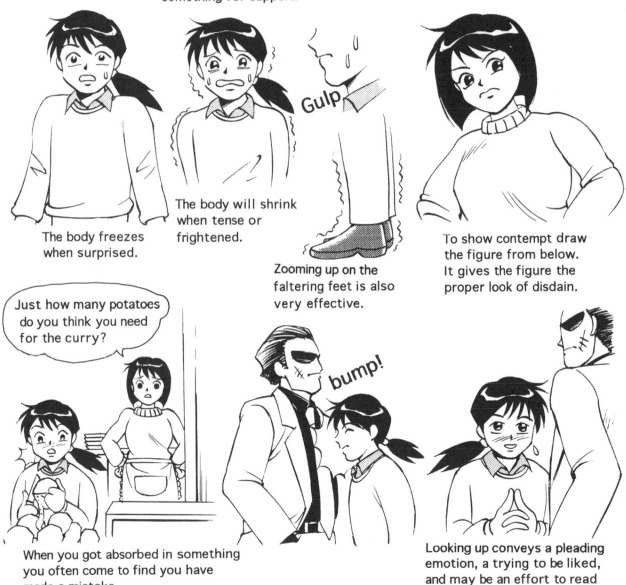

Just how many potatoes do you think you need for the curry?

bump!

When you got absorbed in something you often come to find you have made a mistake.

Looking up conveys a pleading emotion, a trying to be liked, and may be an effort to read the other's face.

107

Effect of background

You can also communicate the character's feeling and state of mind through light, shade and other background effects.

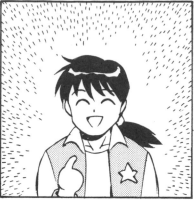

This background is the image of shining light.

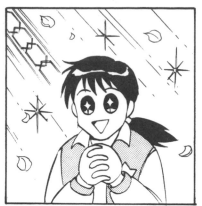

Something bright and warm like flowers and light will create a sense of refreshing delight.

Here, the light shines much more strongly.

Small dots will convey sense of gentleness.

This is an image of delight and happiness. One in a while, you might try experimenting with this kind of background.

Anxiety and suspicion can be conveyed through this kind of background.

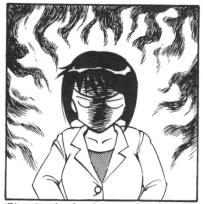

Fire in the background communicates strong anger.

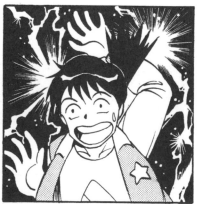

This kind of background well expresses shock and other strong emotion.

Shadow is also an important communicator of atmosphere and state of mind.

Emanating light has different nuances of meaning depending on the intensity of the lines use. It is used to show a visual focal point or speed, and so on.

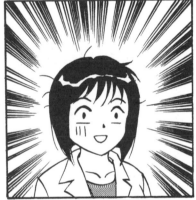

Speed lines, depending upon the strength of lines, create strong emotion and power. There are many ways to use these.

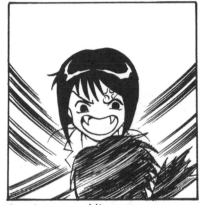

Curving speed lines create more movement. Think about how they can be used to express emotion and power.

Concentrated light like this conveys a flash of awareness, a sudden noticing, or an unfused movement.

Using waves or other strong image you can express strong positive emotion like determination.

Continued · Effect of background

Include props and expressions when
you consider background effects to
show emotion and image of state of mind.

EXAMPLE
DELIGHTS ➡ lights, spring wind, flower leaf, sunny place
ANGER ➡ storm wind, thunder, fire
SORROW ➡ rain, cloudy, winter, twilight, autumn,
　　　　　　falling leaves

Think about the effectiveness of images from nature.
It's also very interesting to use well known images
or cemeteries as props to express emotion.

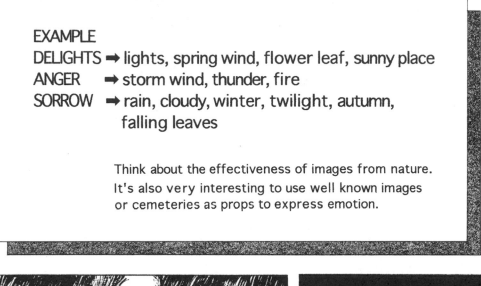

The way the sound effects are written contributes greatly to the feeling.

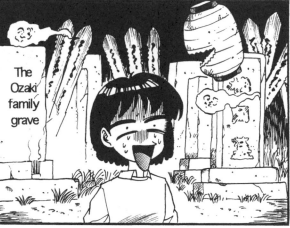

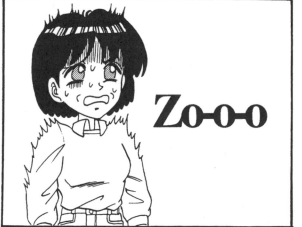

They are both same Zo-o-o but the impression is different
depending on how the actual letters are written.

Sound effects in the picture not only express emotion but also things like speed and power.

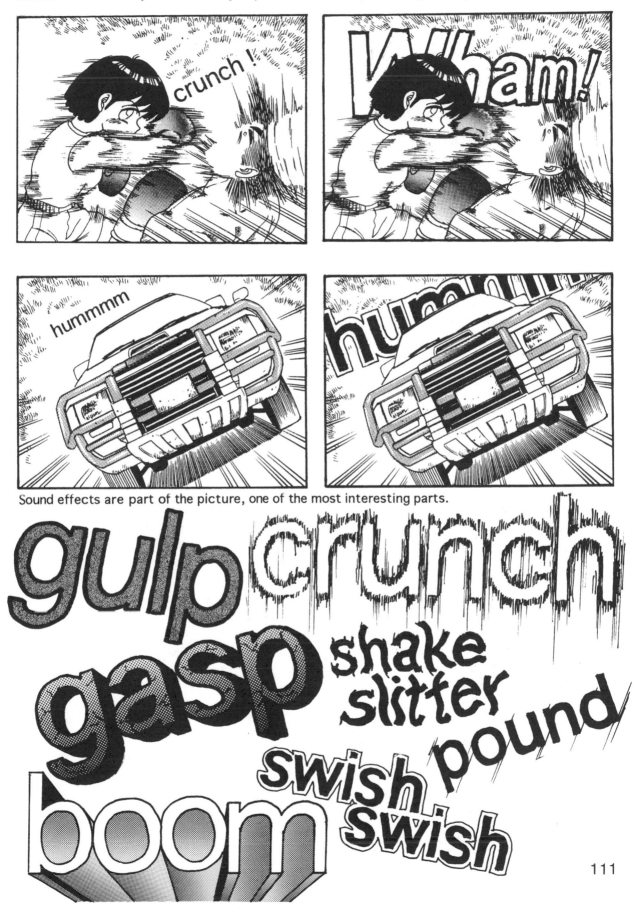

Sound effects are part of the picture, one of the most interesting parts.

A glossary of manga technical terms

A ◆ Atari
 the rough draft of the page/frame
 ◆ Ami (Screen)
 patterns of tone composed of dots
 (There are many types of tones depending on the dot size and density.)
 ◆ Angle
 the angle from which the picture is drawn
B ◆ Back
 background
 ◆ Balloon (Fukidashi)
 the rounded shape in which speech is placed
 ◆ Beta
 an area drawn in black; black beta A brush pen is often used.
 ◆ Benia
 a specialized tone, such as I.C.Screen S171
C ◆ Conté drawing
 rough frame-by-frame sketches based on the scenario
 (This is done before drawing the manuscript, and the words for the frames
 are decided at this time. It is also sometimes called "scripting".)
 Words written in by hand to indicate sound effects etc.
 ◆ Color
 the color manuscript; some times called the four-color
 manuscript
 ◆ "Chara"
 abbreviation of character (This short form "chara" is commonly used
 in Japan.)
 ◆ Cut and paste
 A technique to amend or fix a mistake by cutting out the place with a
 knife and pasting in fresh paper from behind. (This technique is used
 to amend large areas and make scene-by-scene amendments.)
 ◆ Compositioning
 to consider the scenario, or dramatic presentation of the work by
 creating the frames that will comprise it
D ◆ Drop down/drop out
 to miss the deadline, thus causing the publisher to drop the
 cartoon concerned (Strangely, it is always said that "the author has
 become ill".)
 ◆ Deadline
 the time by when the job must be completed
E ◆ Effect lines and concentrated lines
 lines expressing the movement of a person or an object They are also
 used to bring out expression of emotion; curved lines.
F ◆ Flash
 beta flash, balloon flash or tone flash

G ◆ "Grade"

abbreviation for gradation tone such as screening gradation, line gradation, sand gradation etc. This short form "grade" is commonly used in Japan.

◆ Gomukake

to rub out with an eraser

I ◆ #1 (Ichiban)

Tone #61 is commonly called #1 or 10%

K ◆ "Kakimoji"

words written in by hand to indicate sound effects etc.

◆ Kezuri (erasure)

a technique for toning, such as dimming the light, expressing a sense of solidity, etc.

◆ Koma

one frame

L ◆ Layout

the composition of the background, character and the angle of a frame

M ◆ Mihiraki

1. a wide-spread page
2. to draw one cut of drawing onto the two pages in order to make it more impressive

◆ Moiré

the wavy pattern that can emerge when double-pasting screening tones

N ◆ Nyuko

delivery of the manuscript to the publishing company; the day when it is delivered; deadline

◆ Nijubari (double pasting)

layering two tones (and being careful to avoid a moiré effect)

◆ Nuki

1. ending a line by sweeping it rather than finishing it with a stop at the end
2. the instruction to discharge in white the area indicated

◆ "Name"

the script placed in balloons

◆ Nombré

a page; the page count

P ◆ "Pers" (pasu)

abbreviation for "perspective": to express a 3-D effect using perspective

◆ Patting

to tap lightly on the drawing paper with an inked cotton gauze or sponge to create the effect of fog and smoke
It is also called "pon pon", "tataki" and/or "tampo" in Japanese.

◆ Plot

rough planning out of a story based on a character you have in mind

◆ Pen'ire

to draw in black (same as sumi'ire)

R ◆ Round shape

abbreviation for a round ruler; a ruler used to draw curved lines

◆ Retake

 Redoing

S ◆ Sashi

 abbreviation for a ruler. (This word is commonly used in Japan.)

◆ #3 (Sanban)

 screening tone #63 generally called #3

 Some times it is also called "30%".

◆ Scenario

 the story written out in an itemized frame by frame way

◆ Shashoku

 abbreviation for "shashin shokuji", or photocomposition

◆ Sumiire

 filling in with black

◆ Sand

 a sand tone

◆ Sennuke

 forgetting about a line when filling in with black although the line is

 present in the original draft (It is very difficult to find it yourself; it

 is often picked up by an assistant, often when you are using the eraser.)

T ◆ Tachikiri

 to enlarge the picture so that the edge of the frame needs the edge of

 the page

◆ Touch

 drawing by pressing the pen heavily or lightly to create accents

◆ Tanto

 the employee of a publisher charged with making the arrangement with

 the cartoonist and delivering the manuscript; the coordinator who liaisons

 with the cartoonist with the company (Beginners sometimes get advice

 from the tanto.)

◆ Template

 a round shape to draw circles and ellipses with

◆ Tone

 A clear film with different patterns such as screening dots, stripes, sand

 gradation etc. The film is glued on the back and you press it down and rub

 to apply. Recently, many different patterns have become available and

 can be used for a variety of situations.

◆ Trace

 to draw a rough sketch and/or trace a photo through the trace scope

◆ Two colors

 a douchrome manuscript in red and black

U ◆ Up

 1. the work is completed

 2. the day of the deadline

W ◆ White

 amending a large portion or inserting a highlight

◆ White tone

 A tone in white color; an ordinary tone that will be printed in white instead

 of black

◆ Waku

 the frame line

SUMMARY

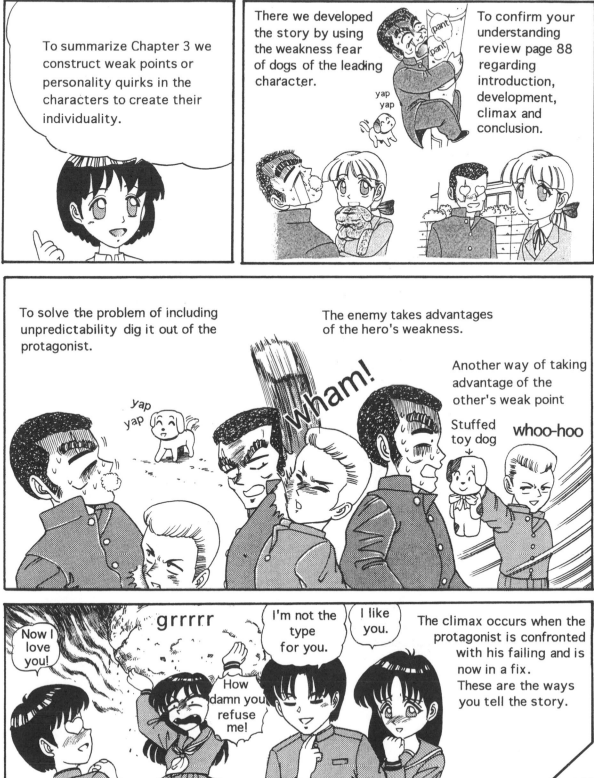

To summarize Chapter 3 we construct weak points or personality quirks in the characters to create their individuality.

There we developed the story by using the weakness fear of dogs of the leading character.

yap yap

pant pant

To confirm your understanding review page 88 regarding introduction, development, climax and conclusion.

To solve the problem of including unpredictability dig it out of the protagonist.

The enemy takes advantages of the hero's weakness.

yap yap

Wham!

Another way of taking advantage of the other's weak point

Stuffed toy dog

whoo-hoo

Now I love you!

grrrrr

How damn you refuse me!

I'm not the type for you.

I like you.

The climax occurs when the protagonist is confronted with his failing and is now in a fix.
These are the ways you tell the story.